Glorious Flowers

COLORING BOOK

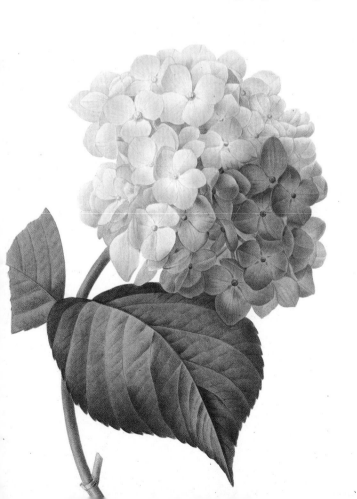

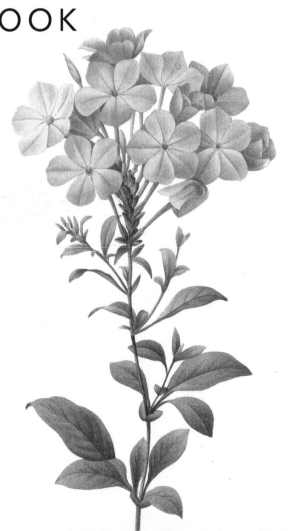

SIRIUS

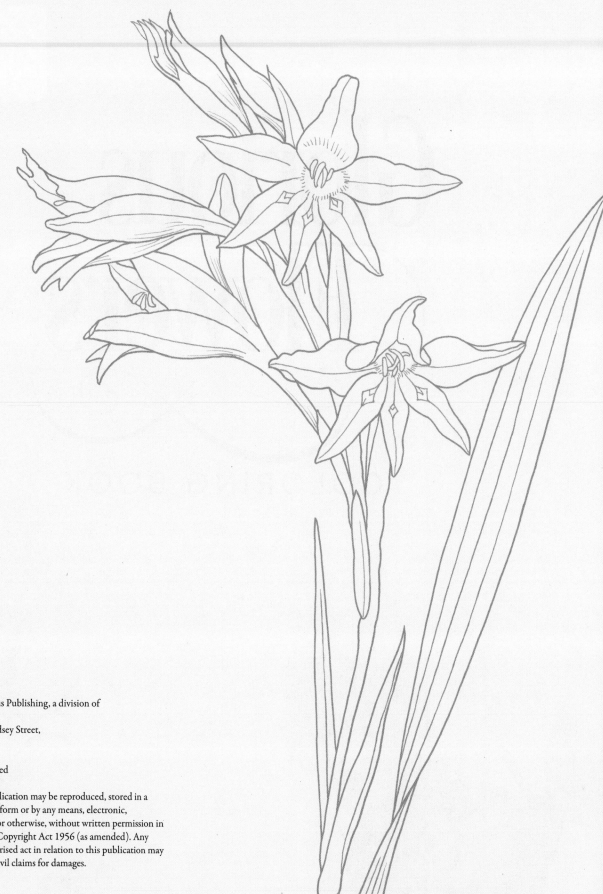

SIRIUS

This edition published in 2022 by Sirius Publishing, a division of
Arcturus Publishing Limited,
26/27 Bickels Yard, 151–153 Bermondsey Street,
London SE1 3HA

ISBN: 978-1-3988-2130-9
CH005274NT
Supplier 29, Date 0422, PI 00001861

Printed in China

Introduction

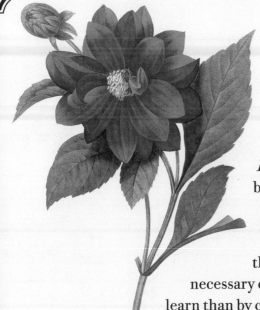

Flowers have always made fascinating subjects for artists and they are a wonderful challenge to reproduce. Following on from the first title, *Coloring Flowers*, this book contains a selection of more than 40 beautiful flower paintings by renowned botanical artists for you to color.

The simple line drawings are reproduced directly from the artists' sketches and are waiting for you to add all the necessary color and detail. Remember, there's no better way to learn than by copying the masters.

Watercolor paint or colored pencils are the best mediums to use for these illustrations – you may find the latter easier. Be sure to blend your colors and follow the natural direction of the subject's textures, working along the lines of the leaves and petals to faithfully re-create these natural wonders.

All of the artwork in this book has been drawn from either the *L'Illustration horticole*, a 19th-century Belgian journal founded by Jean Jules Linden in 1854 and illustrated by some of the finest botanical artists and lithographers of the day, including A. Goossens, P. De Pannemaeker and J. Goffart; or from *Choix des plus belles Fleurs* (*Choice of the Most Beautiful Flowers*), published in 1827 and illustrated by Pierre-Joseph Redouté. A one-time court artist to Marie Antoinette, Redouté illustrated more than 1800 plant species and remains one of the most famous artists in the genre of botanical painting to this day.

Where available, the Latin names that were provided by the original 19th-century artists have been included underneath each color illustration. The common names are also provided below each line drawing. With such an array of exquisite illustrations to study, you cannot fail to be inspired in your own endeavors.

Key: *List of plates*

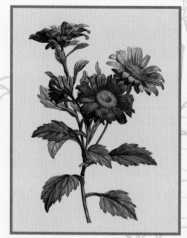

1 *Aster chinensis*
(China aster)

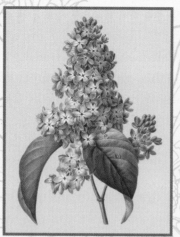

2 *Lilas* (Lilac)

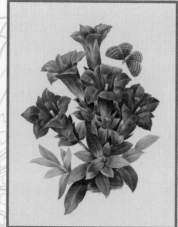

3 *Gentiana acaulis*
(Gentian)

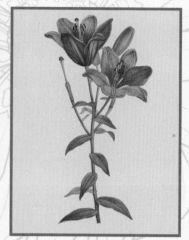

4 *Lilium bulbiferum*
(Tiger lily)

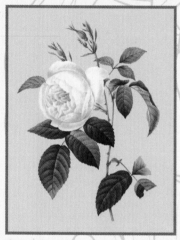

5 *Rosa indica*
(Indian rose)

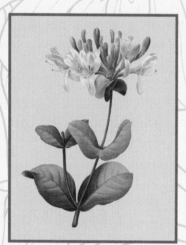

6 *Lonicera*
(Honeysuckle)

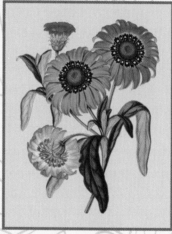

7 *Gazania splendens*
(Treasure flower)

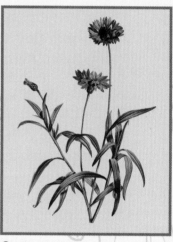

8 *Centaurea cyanus*
(Cornflower)

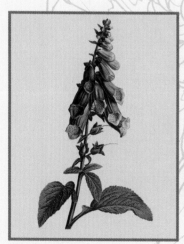

9 *Digitalis purpurea*
(Common foxglove)

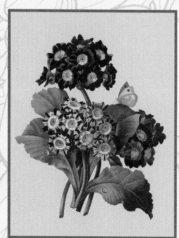

10 *Primula auricula*
(Bouquet of primulas)

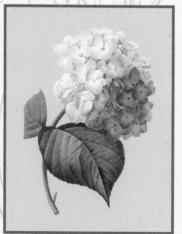

11 *Hortensia*
(Hydrangea)

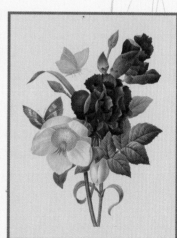

12 Hellebore and
carnations

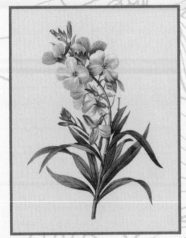

13 *Cheiranthus flavus*
(Wallflower)

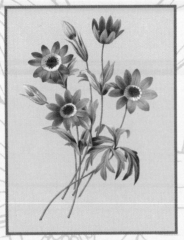

14 *Anemone stellata*
(Broad-leaved anemone)

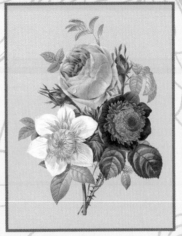

15 Bouquet of rose,
anenome and clematis

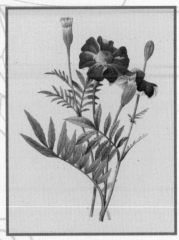

16 *Tagetes* (Marigold)

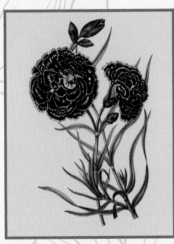

17 *Dianthus albo-nigricans*
(Sweet William)

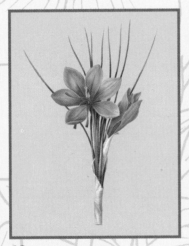

18 *Crocus sativus*
(Saffron crocus)

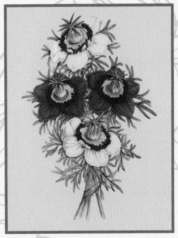

19 Varieties of *Nigella
hispanica (Love-in-a-mist)*

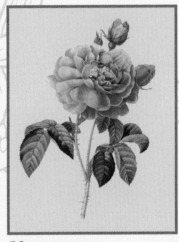

20 *Rosa gallica
aurelianensis*
(La Duchesse d'Orléans)

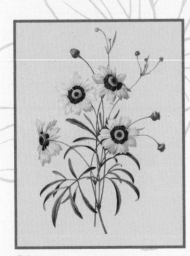

21 *Coreopsis elegans*
(Tickseed)

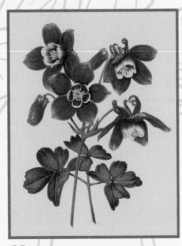

22 *Aquilegia spectabilis*
(Columbine)

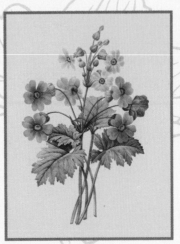

23 *Primula sinensis*
(Chinese primrose)

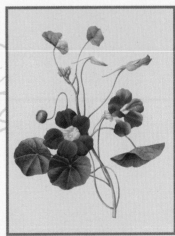

24 *Tropaeolum majus*
(Nasturtium)

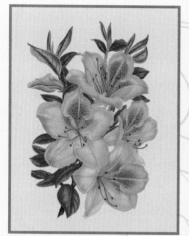

25 *Azalea indica gigantiflora* (Azalea)

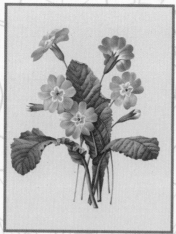

26 *Primavera grandiflora* (Primrose)

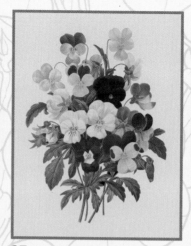

27 Bouquet of pansies

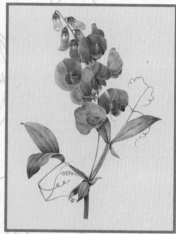

28 *Lathyrus latifolius* (Everlasting pea)

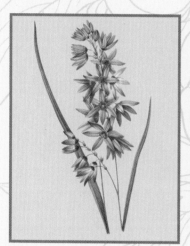

29 *Ixia viridiflora* (Turquoise ixia)

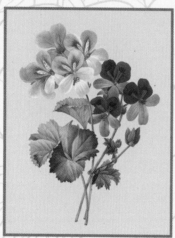

30 Geranium variety

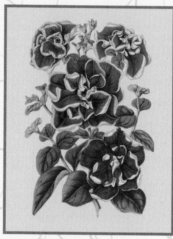

31 *Petunia inimitabilis* (Petunia)

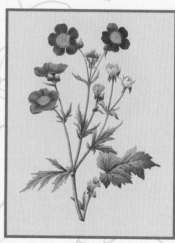

32 *Geum coccineum* (Dwarf orange avens)

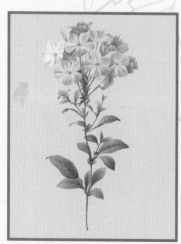

33 *Plumbage caerulea* (Plumbago)

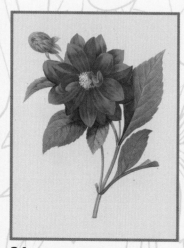

34 Double dahlia

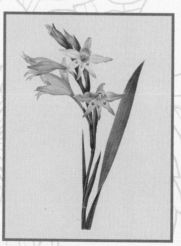

35 *Gladiolus cuspidatus* (Corn flag)

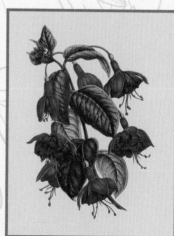

36 *Fuchsia solferino* (Fuchsia)

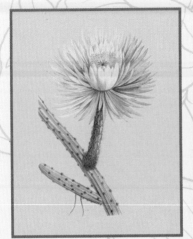

37 *Cactus grandiflorus* (Night-blooming cereus)

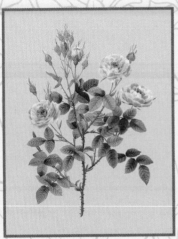

38 *Rosa pomponia* (Pompon rose)

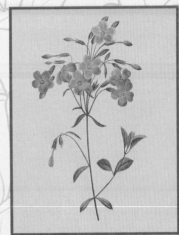

39 *Phlox reptans* (Phlox)

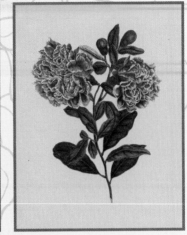

40 *Punica granatum* var. *legrelliae* (Flowering pomegranate)

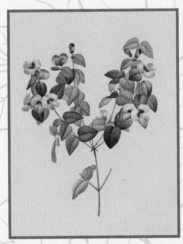

41 *Platylobium* (Flat-pea)

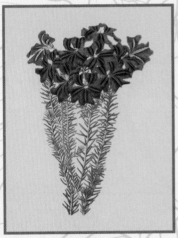

42 *Lechenaultia biloba* (Blue lechenaultia)

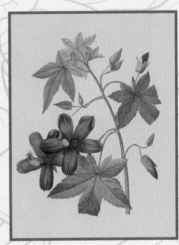

43 *Lavatera phoenicea* (Tree mallow)

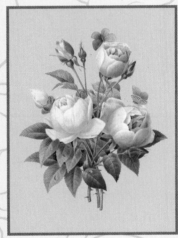

44 Bouquet of roses

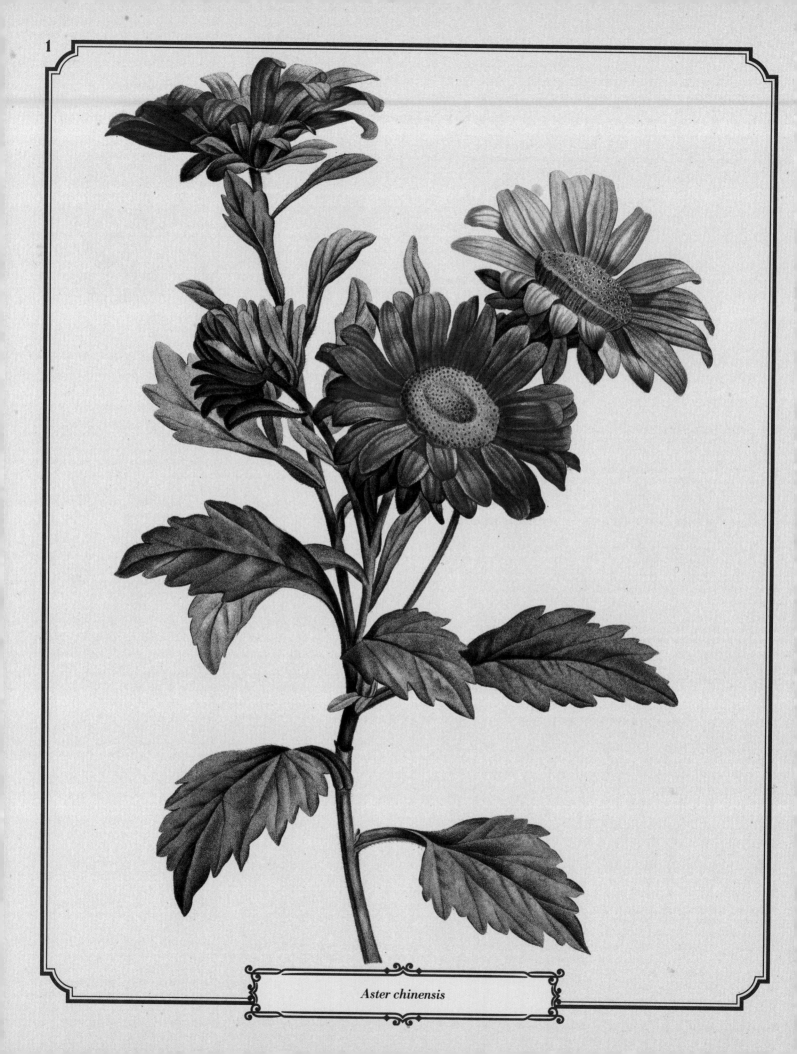

Aster chinensis

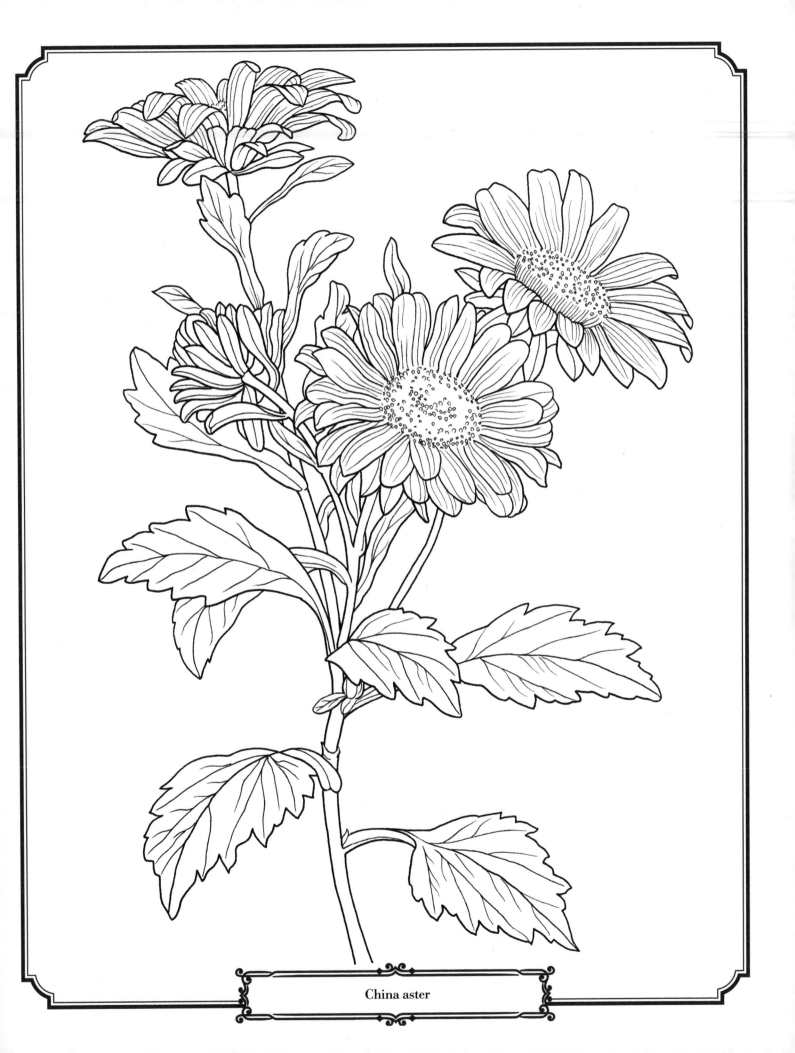

China aster

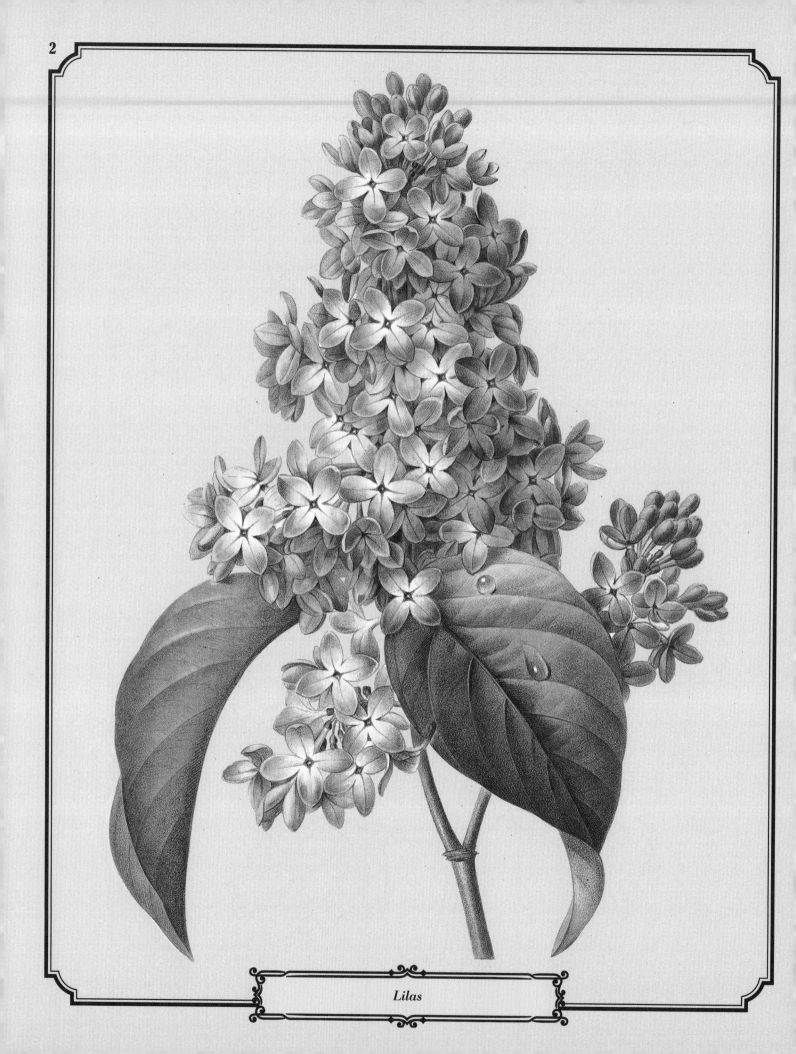

Lilas

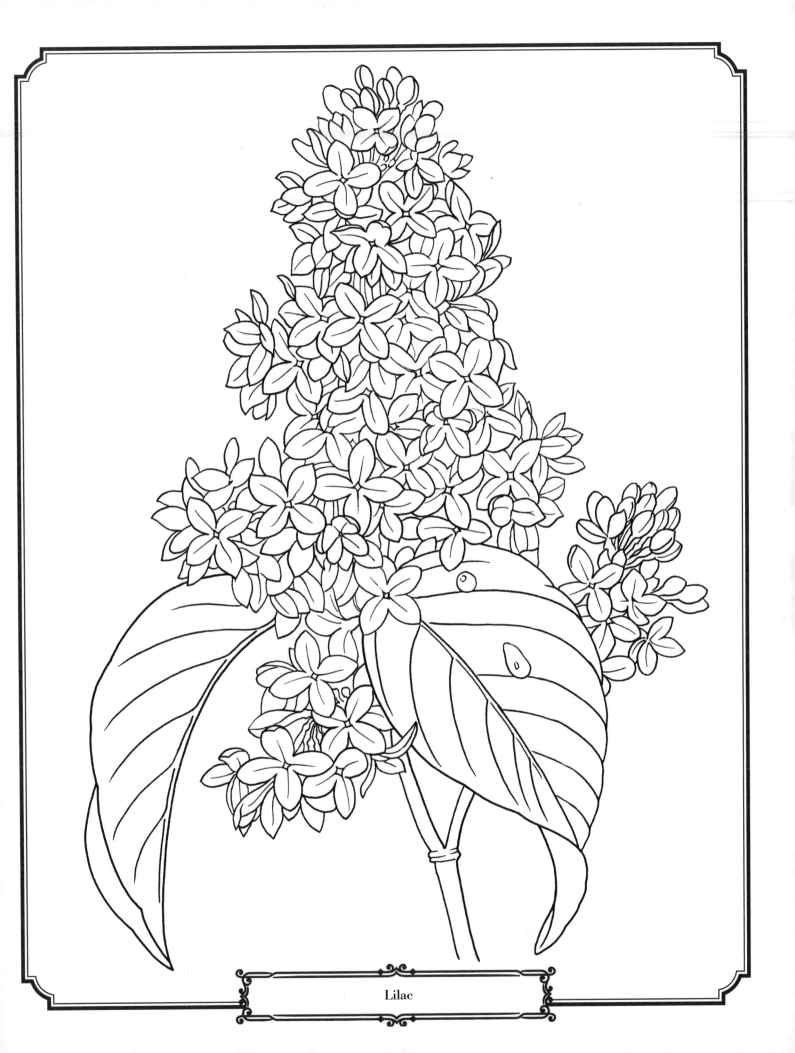

Lilac

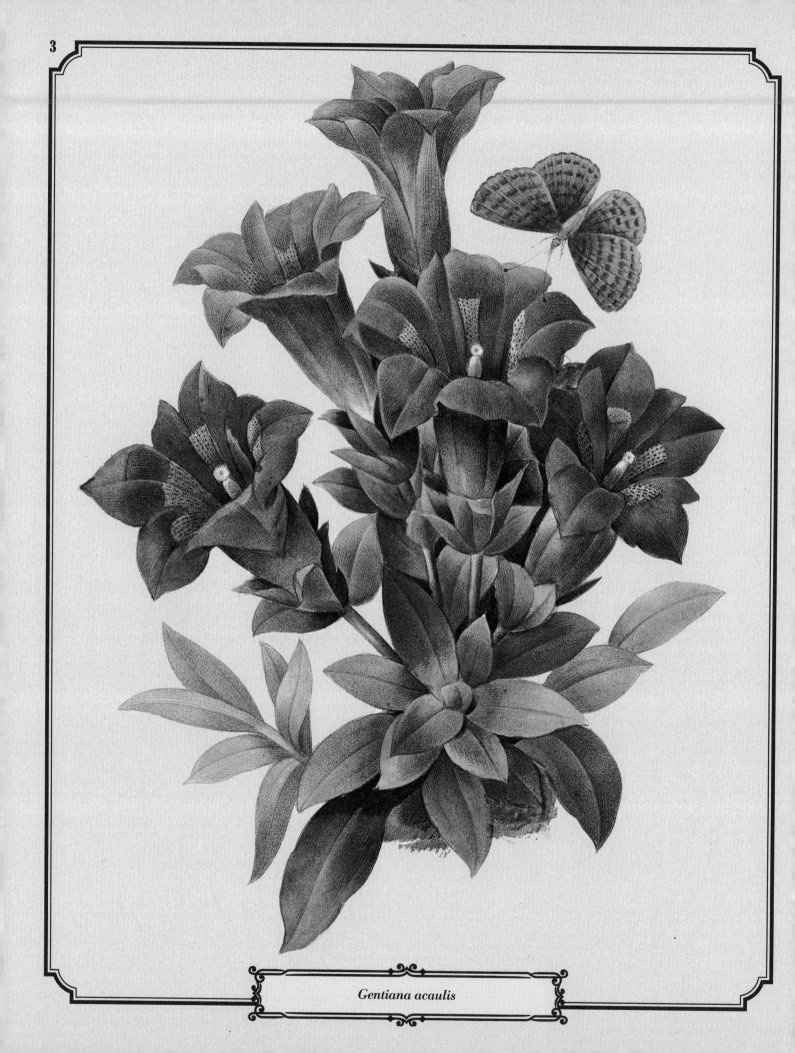

Gentiana acaulis

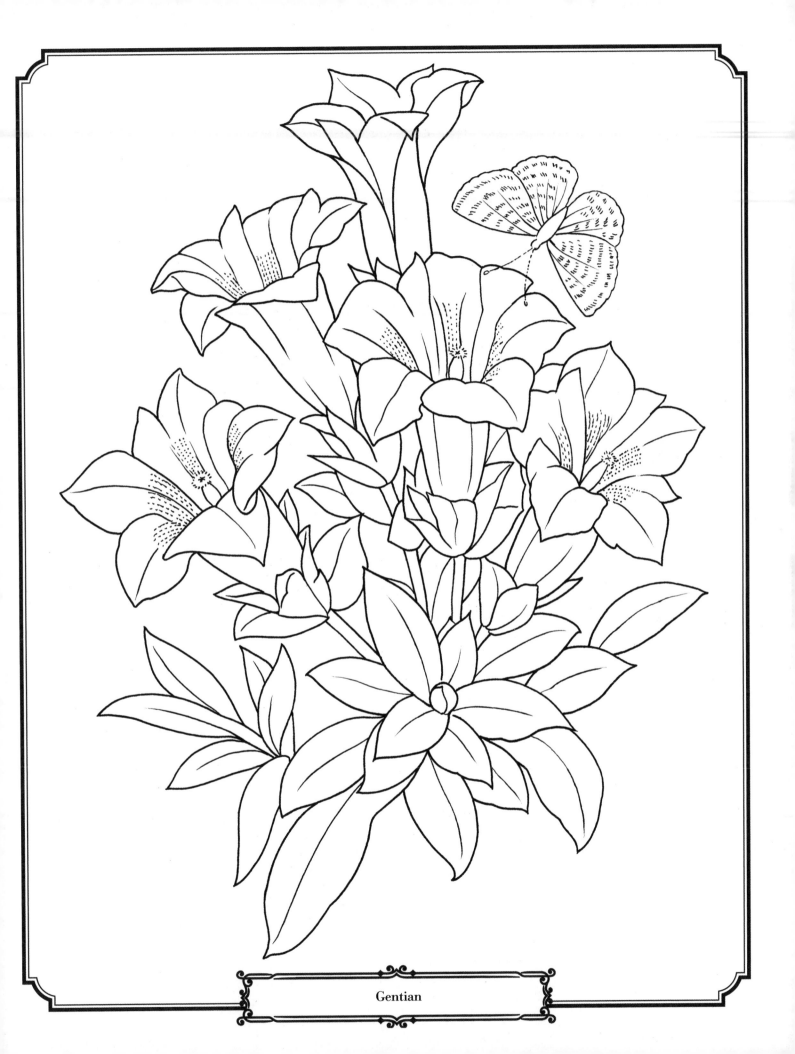

Gentian

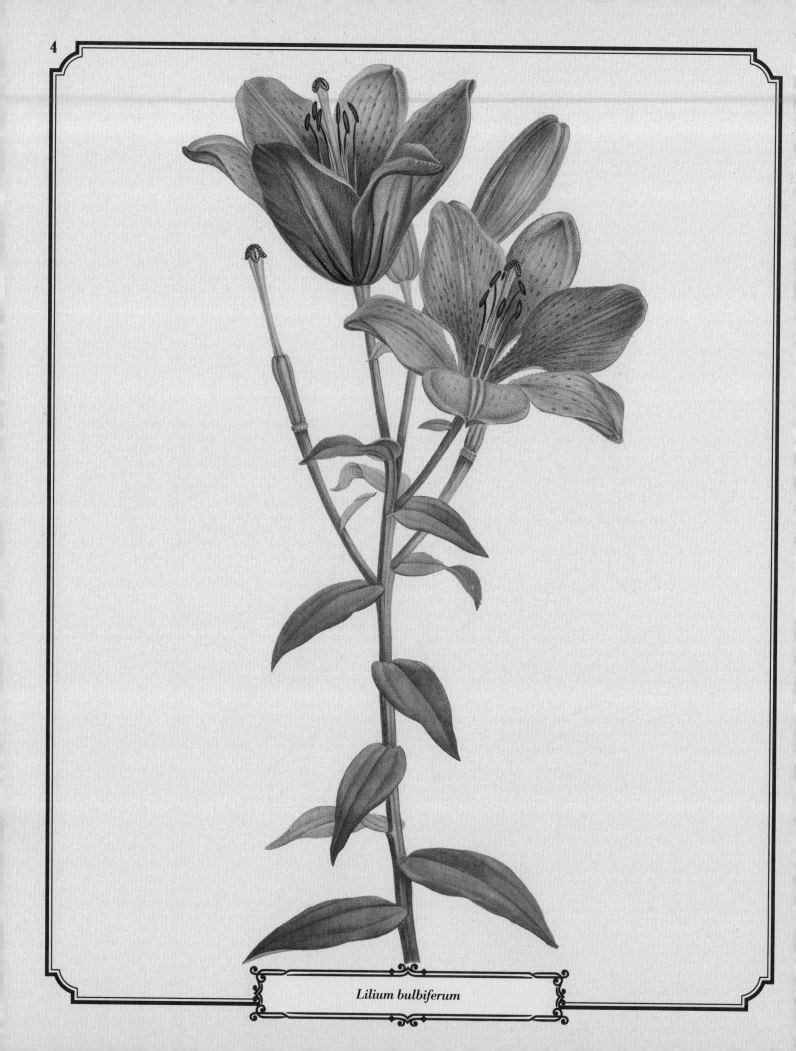

Lilium bulbiferum

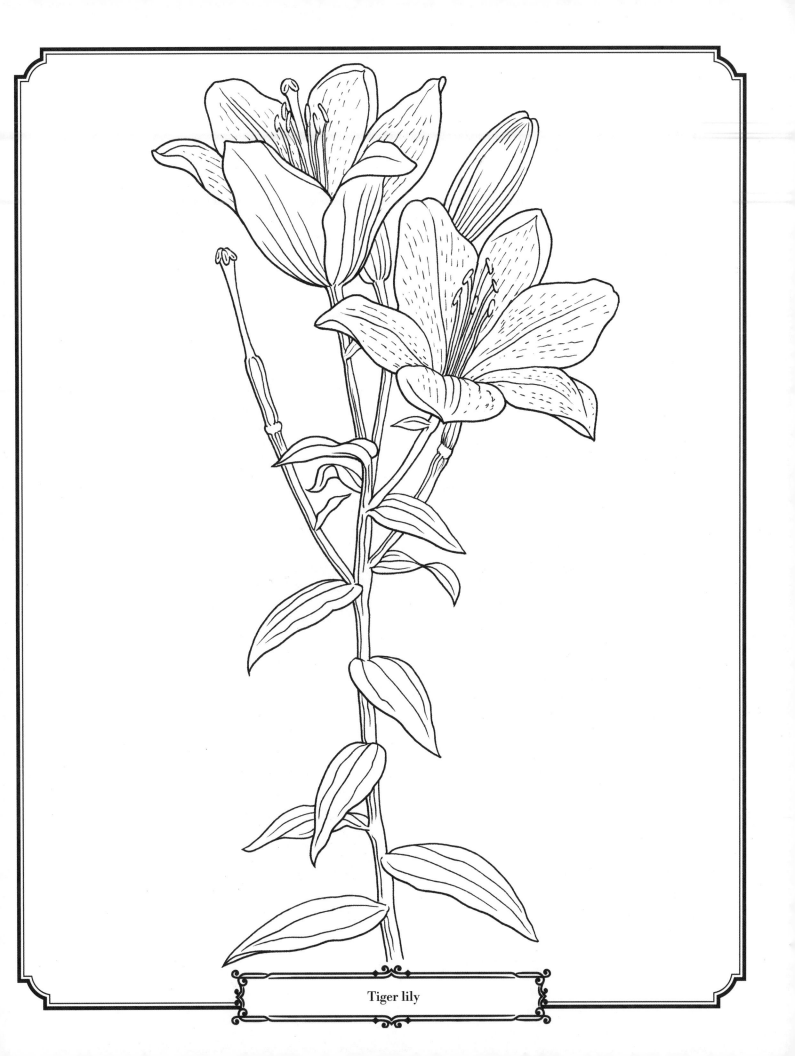

Tiger lily

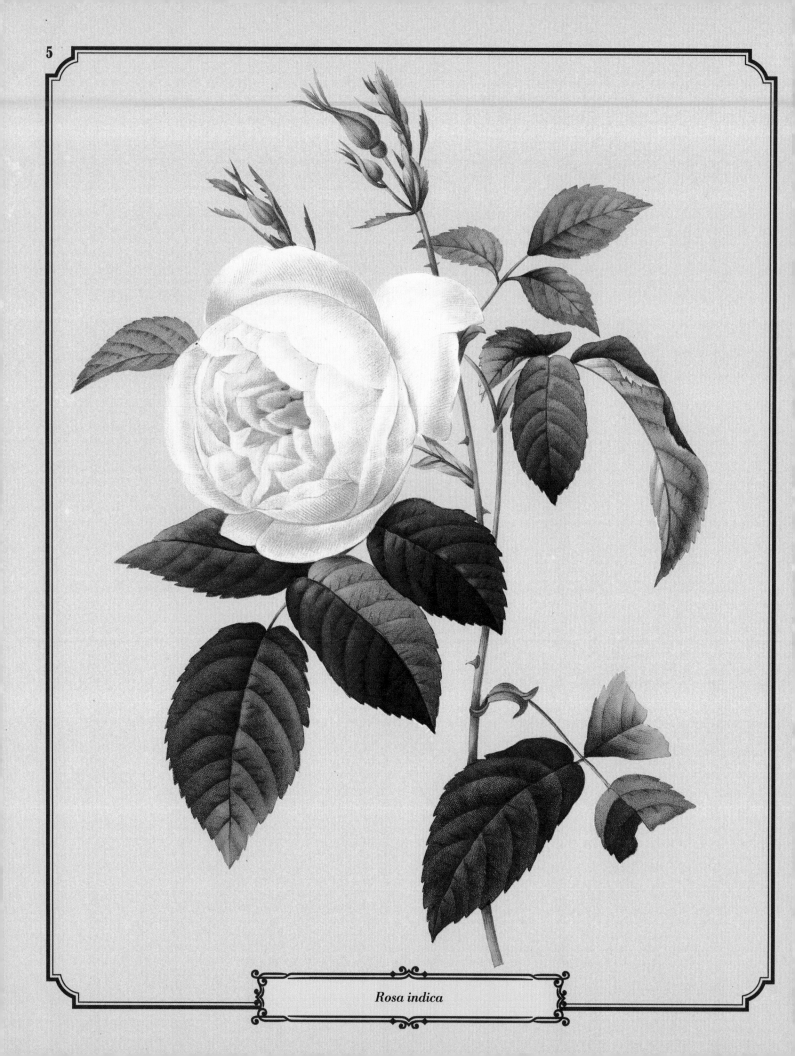

Rosa indica

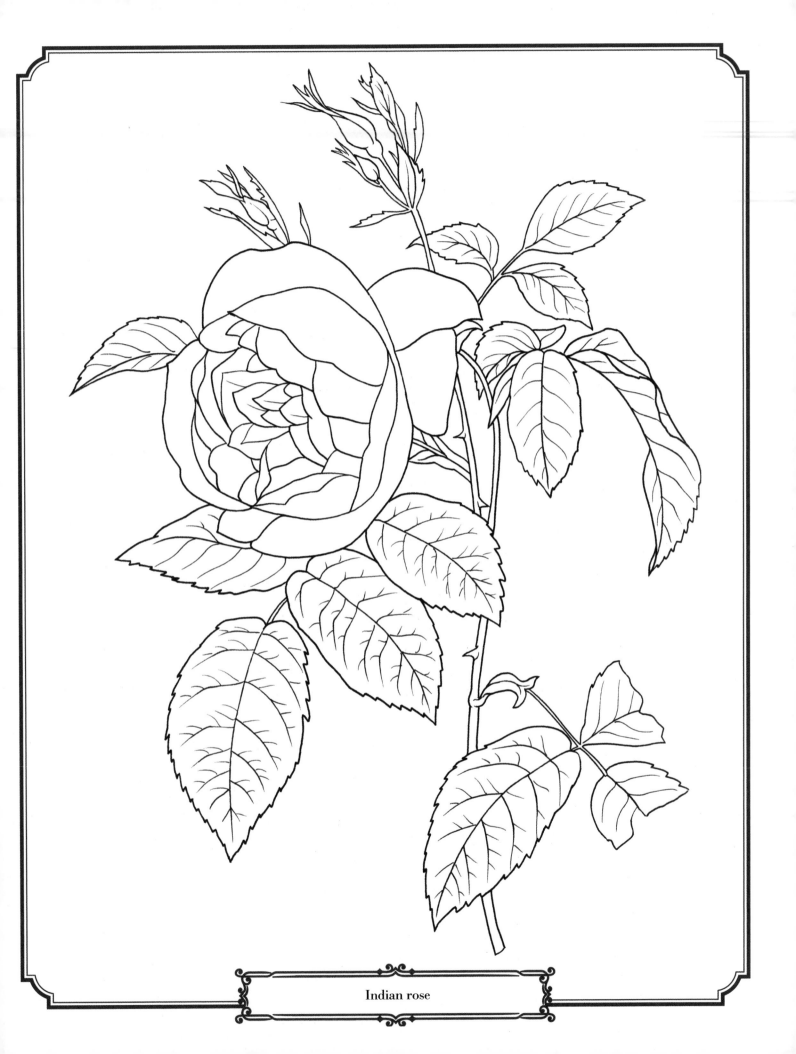

Indian rose

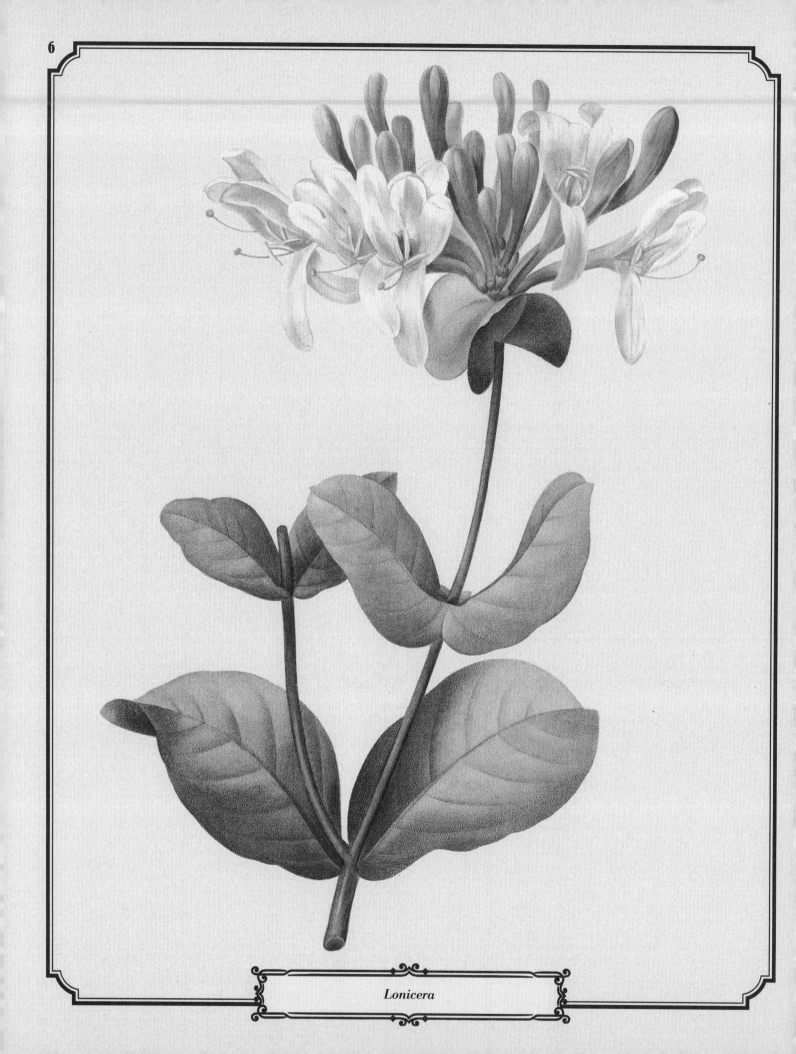

Lonicera

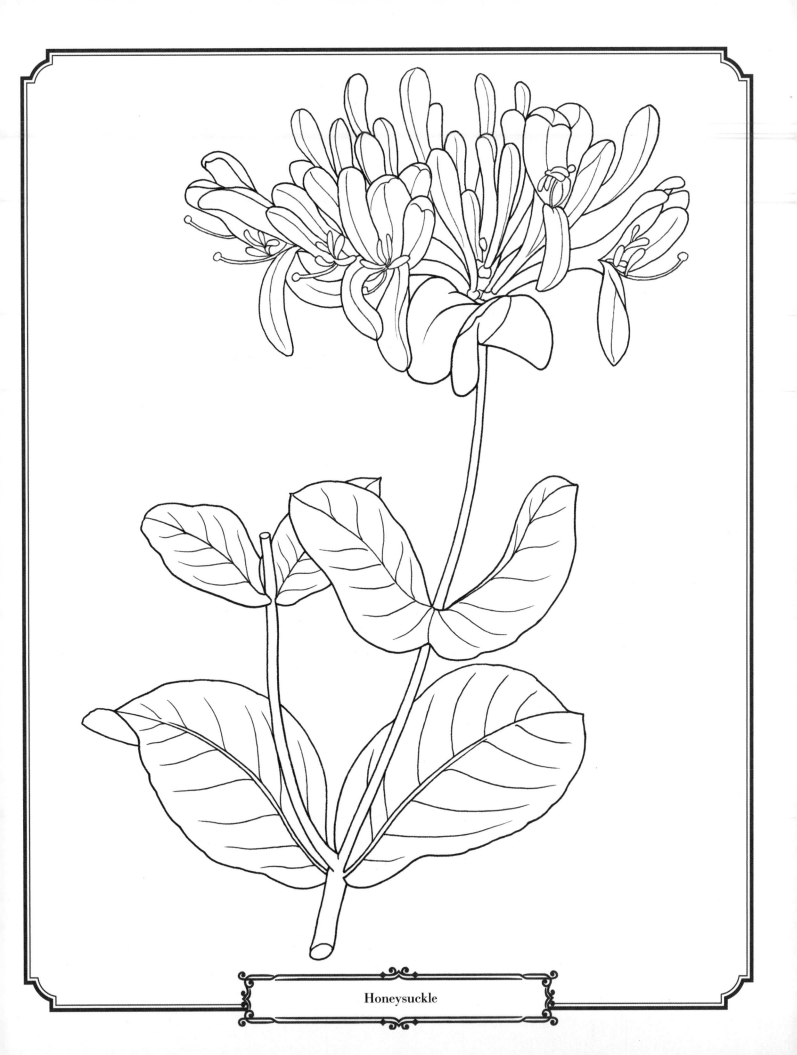

Honeysuckle

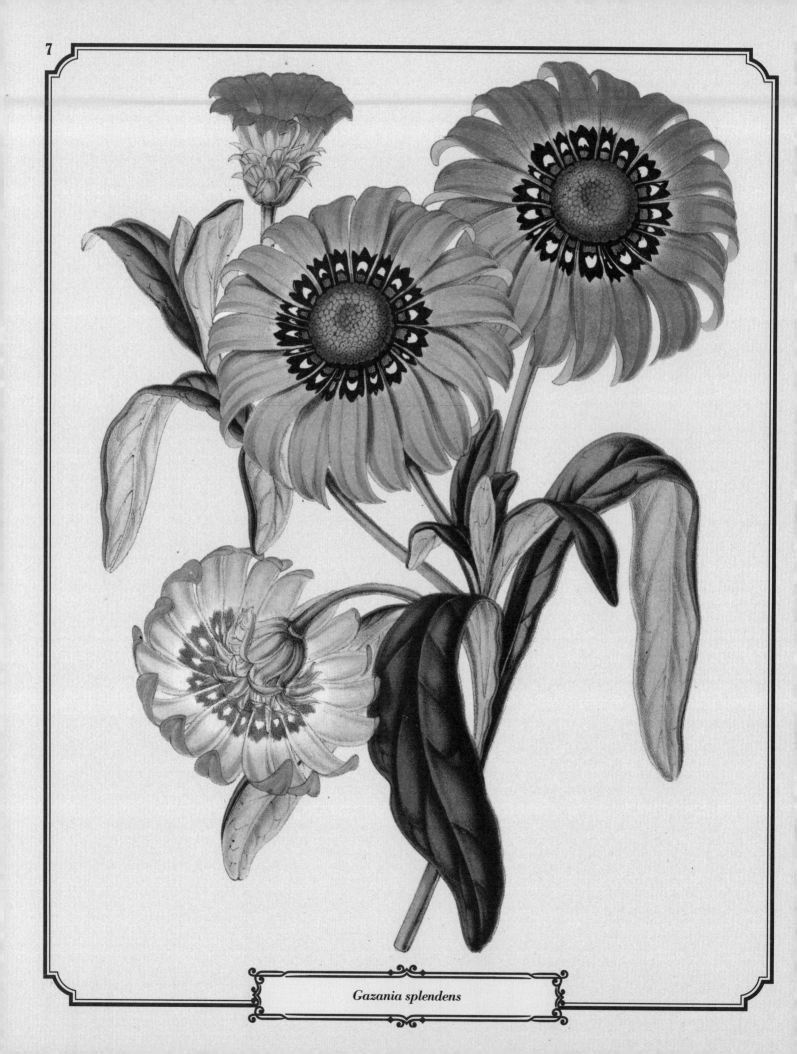

Gazania splendens

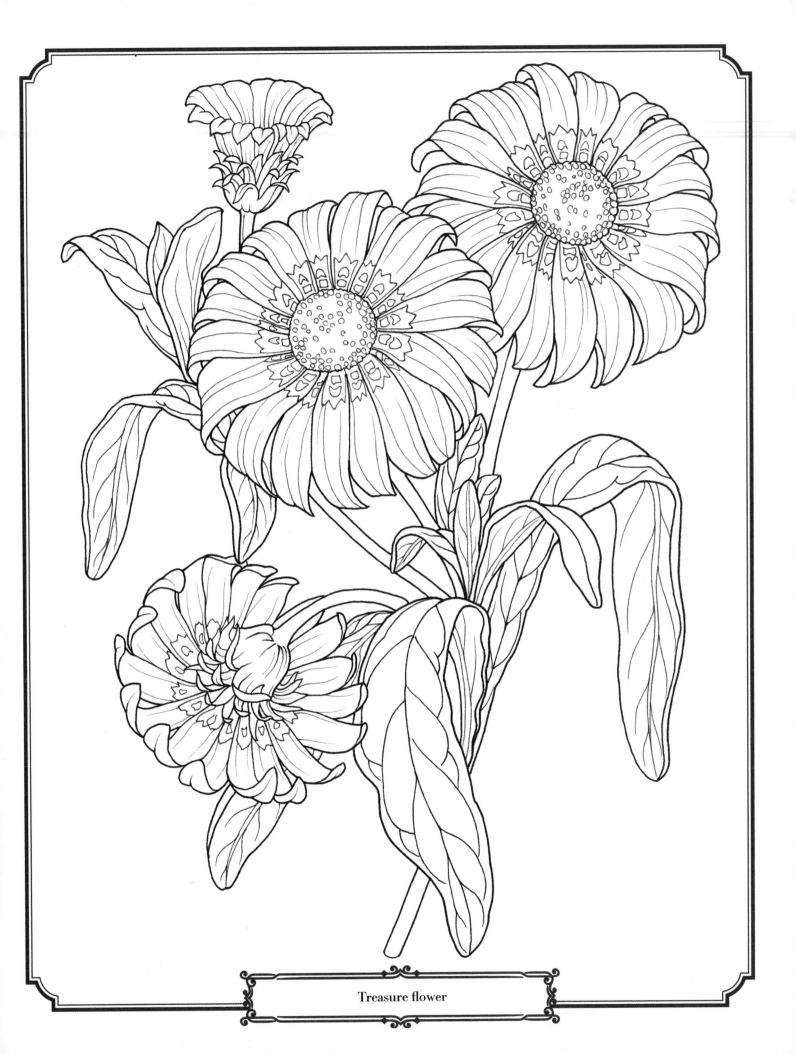

Treasure flower

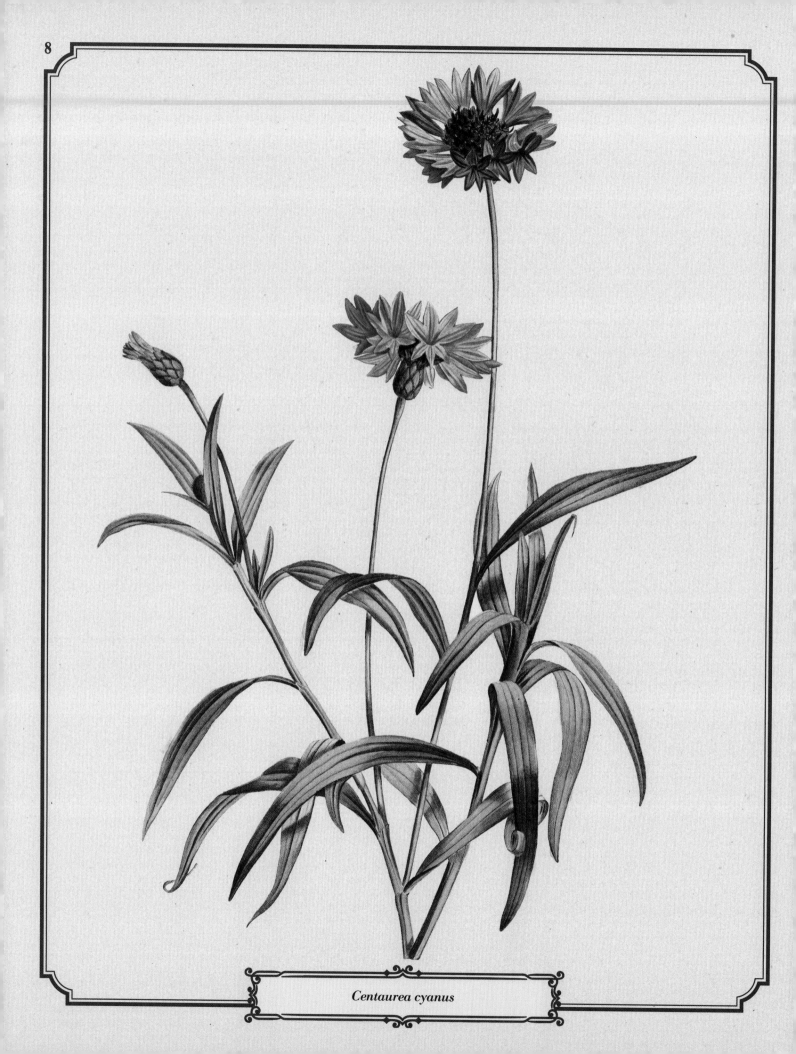

Centaurea cyanus

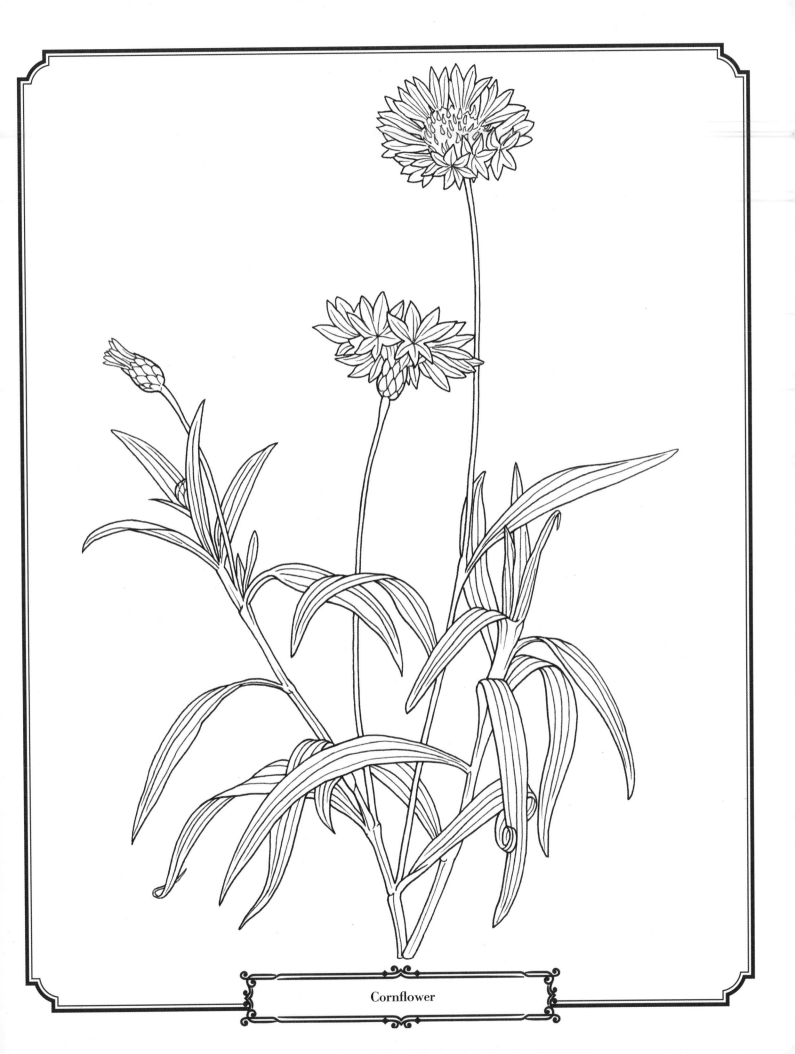

Cornflower

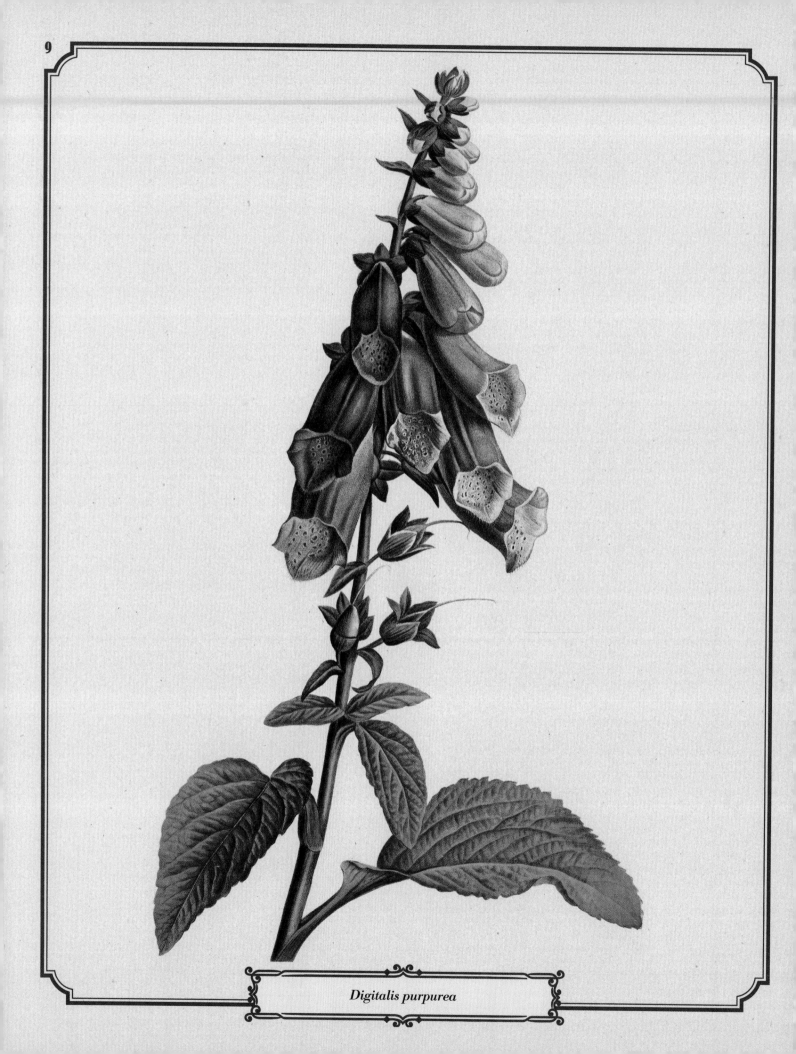

Digitalis purpurea

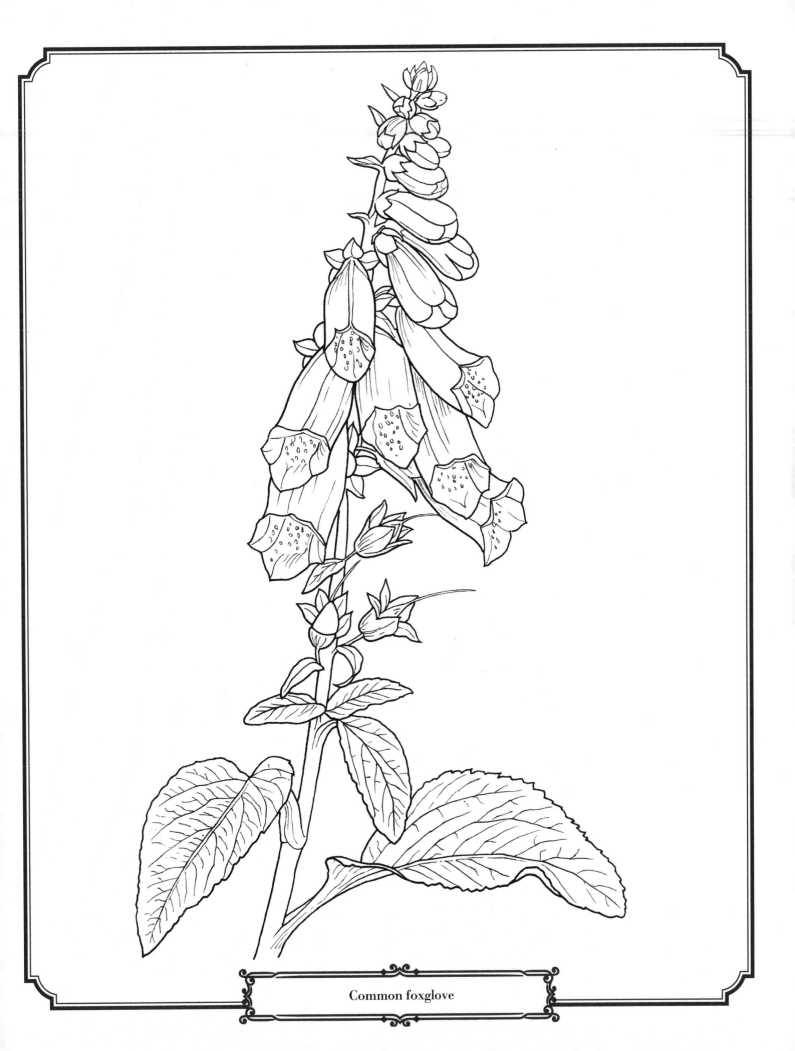

Common foxglove

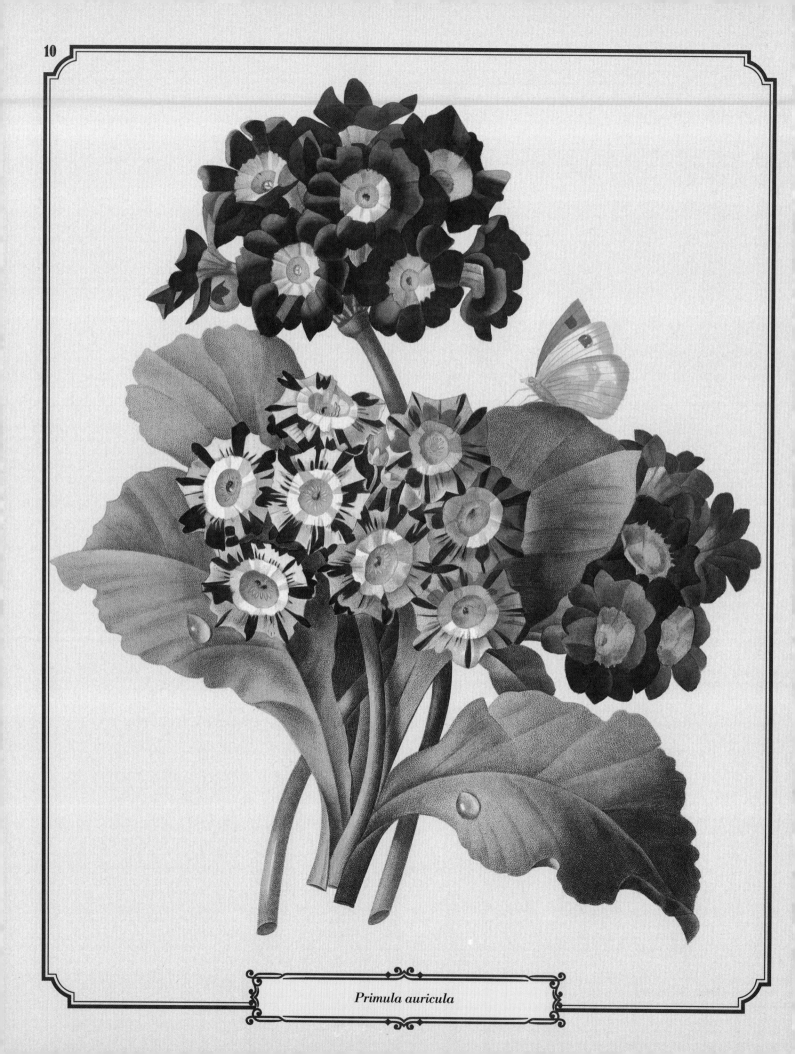

Primula auricula

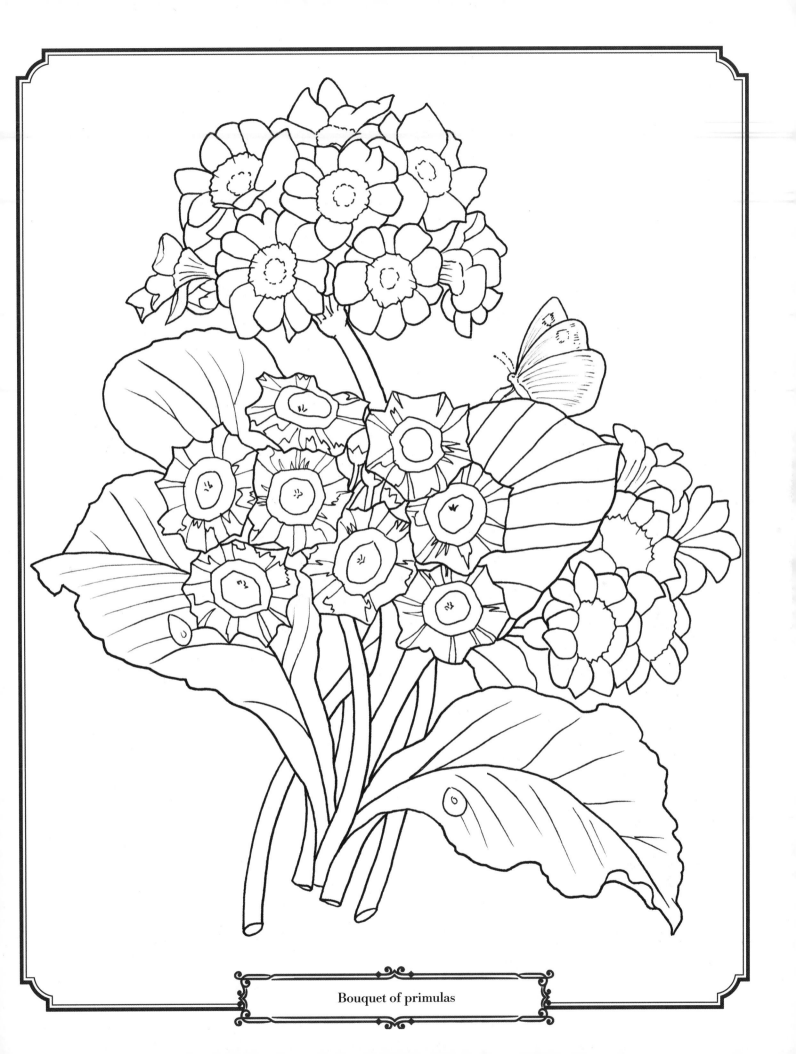

Bouquet of primulas

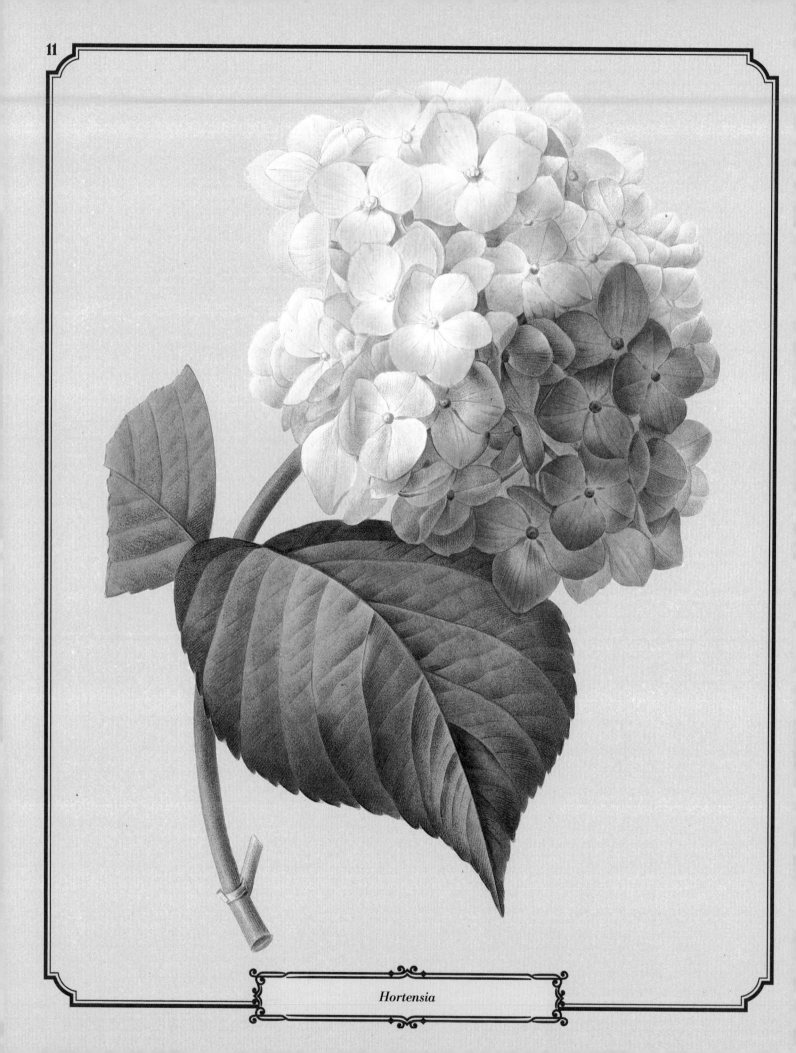

Hortensia

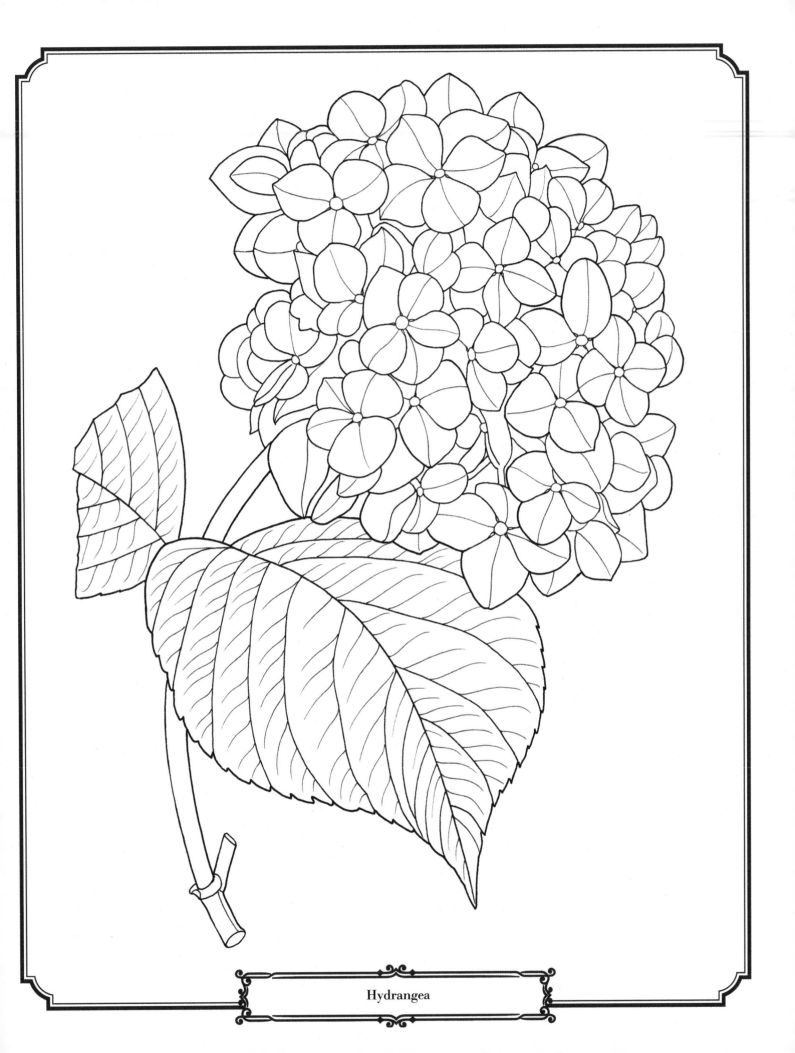

Hydrangea

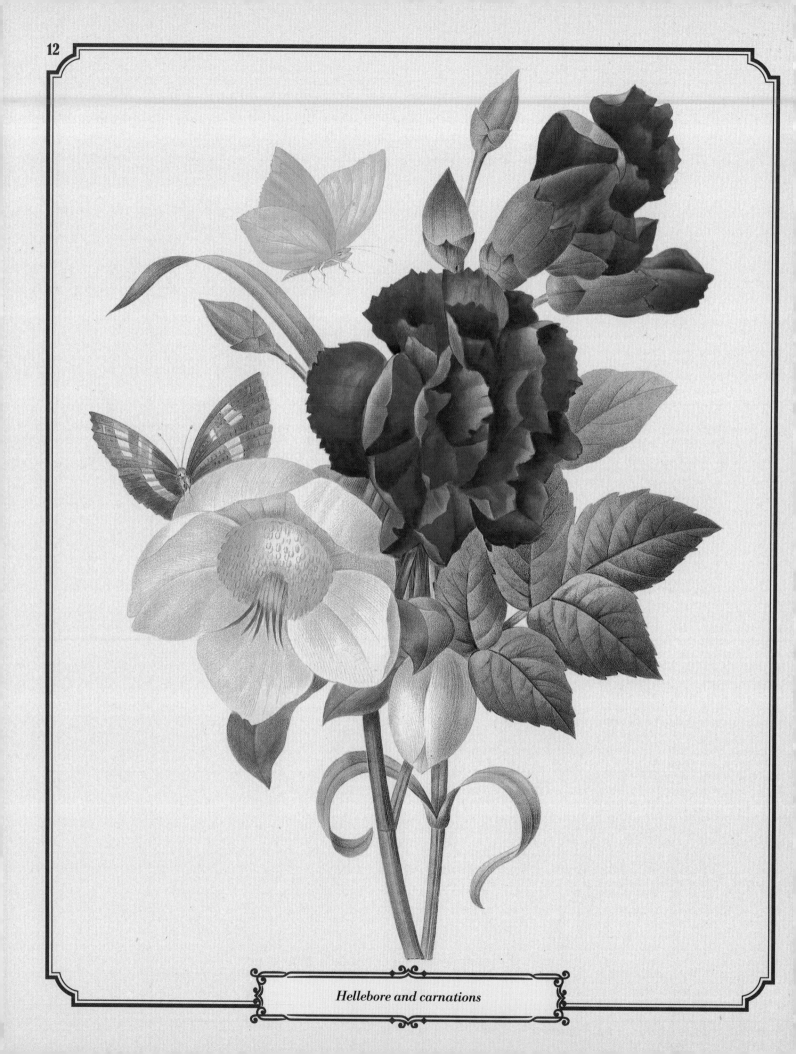

Hellebore and carnations

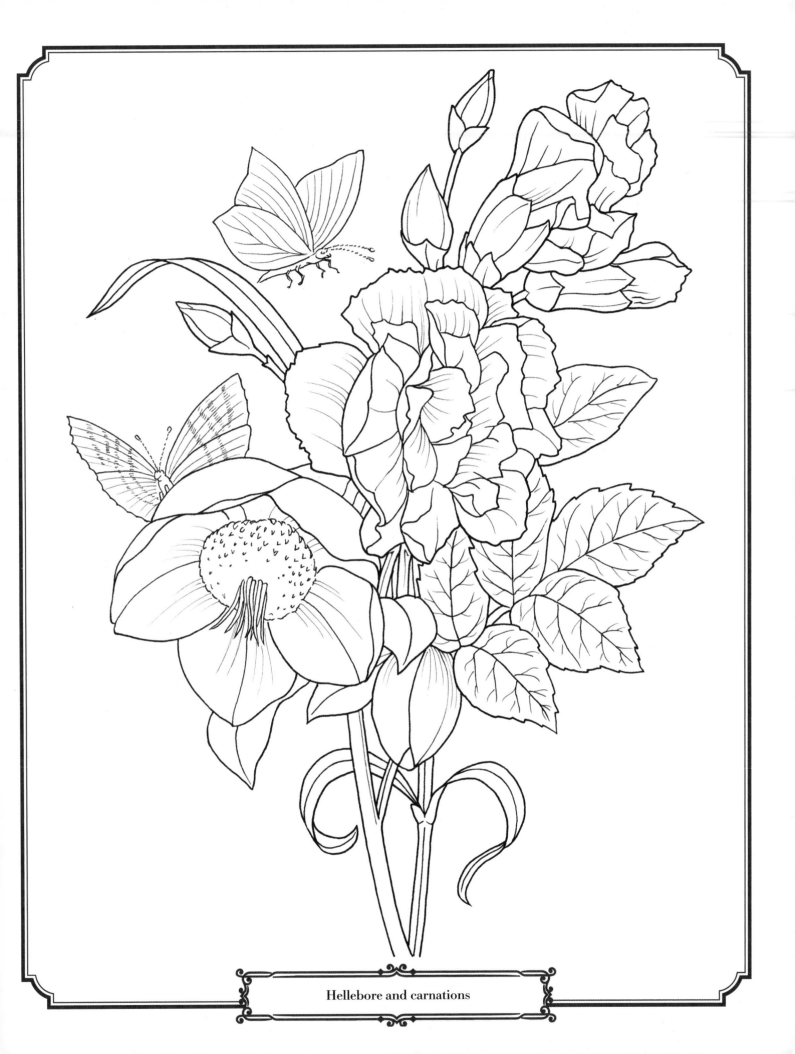

Hellebore and carnations

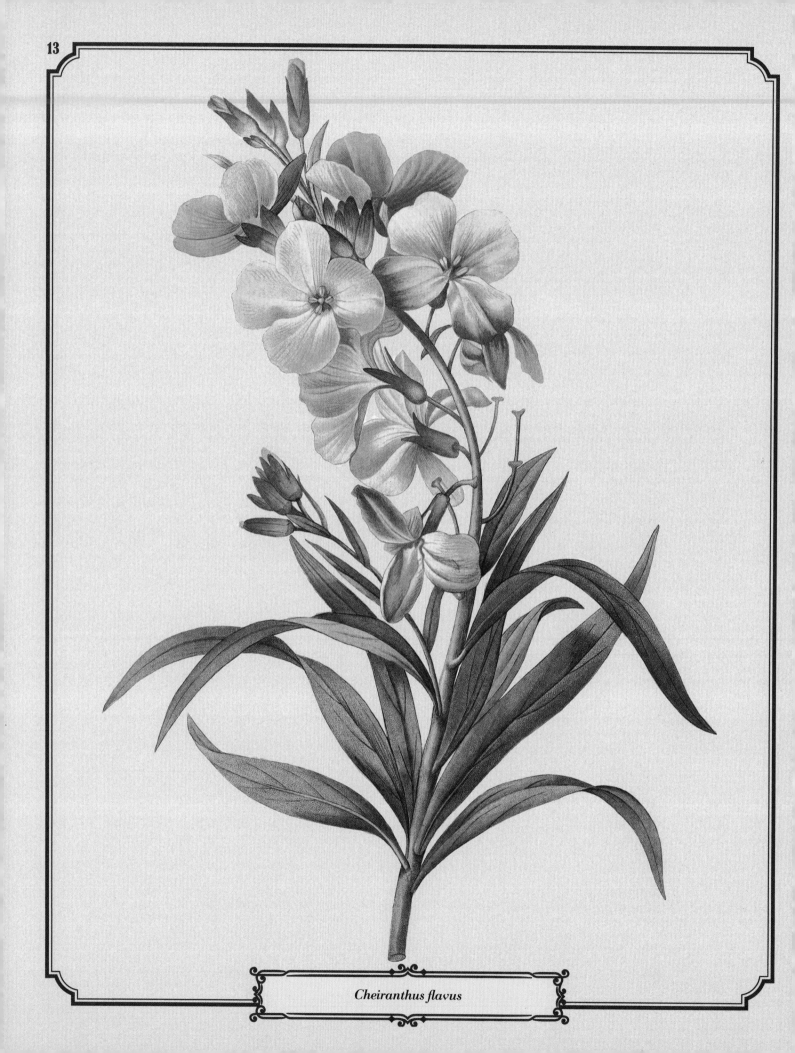

Cheiranthus flavus

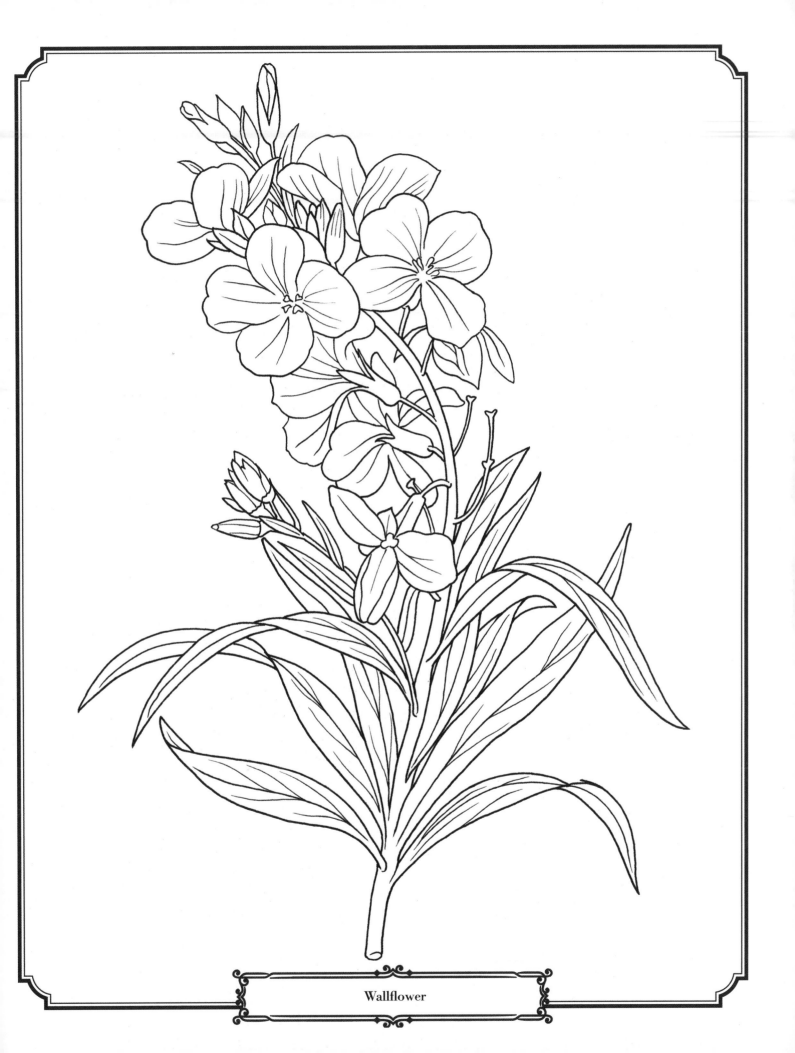

Wallflower

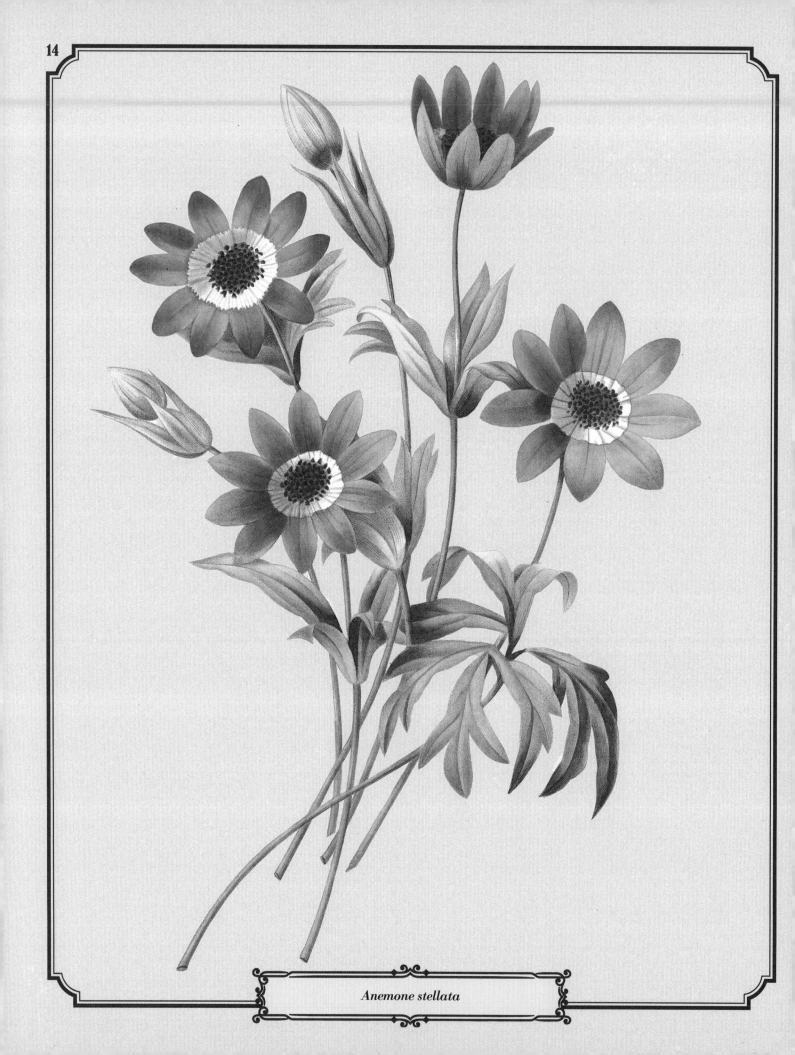

Anemone stellata

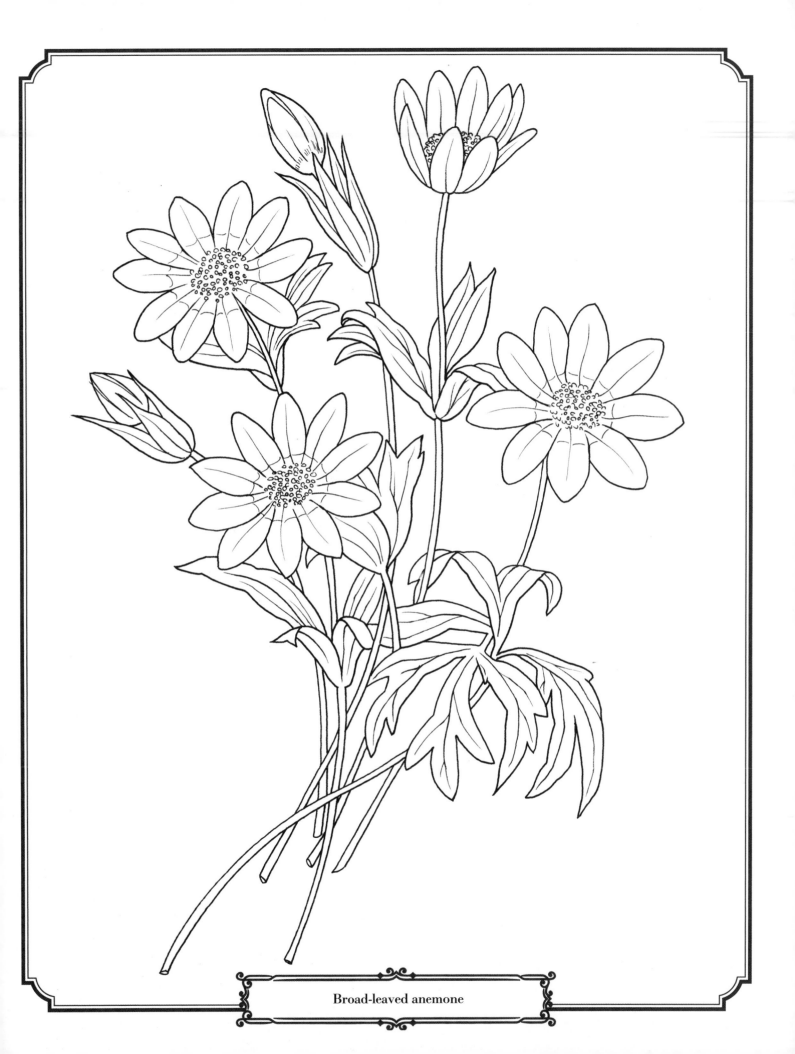

Broad-leaved anemone

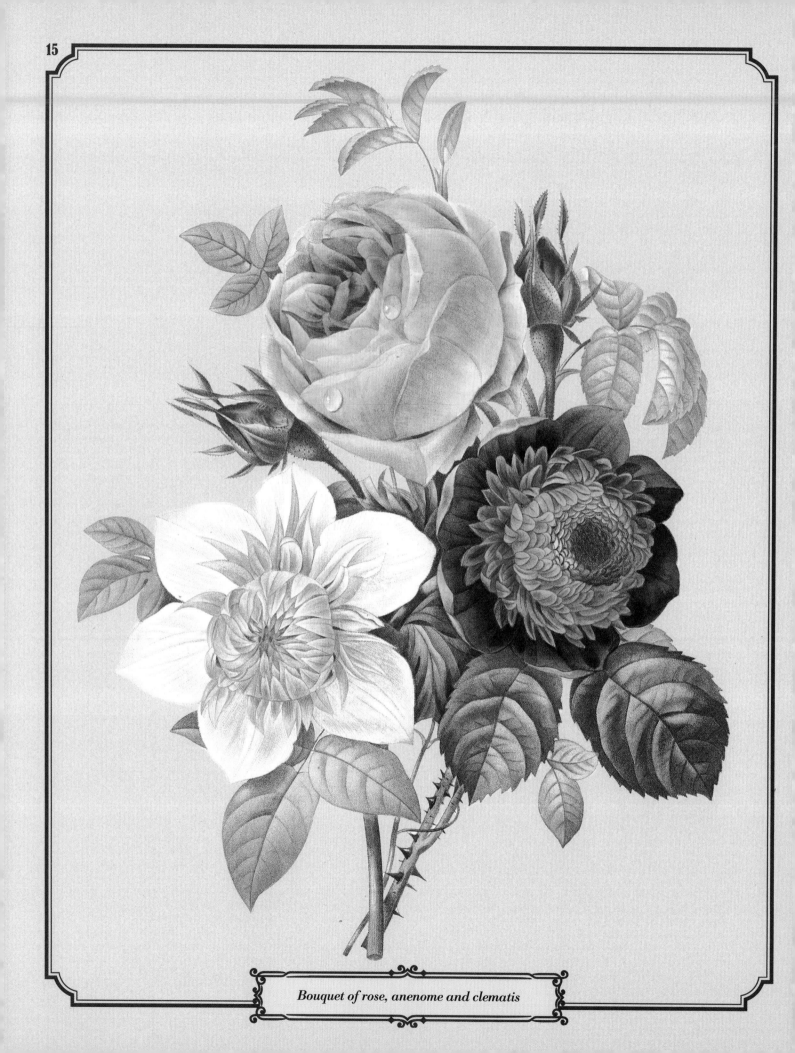

Bouquet of rose, anenome and clematis

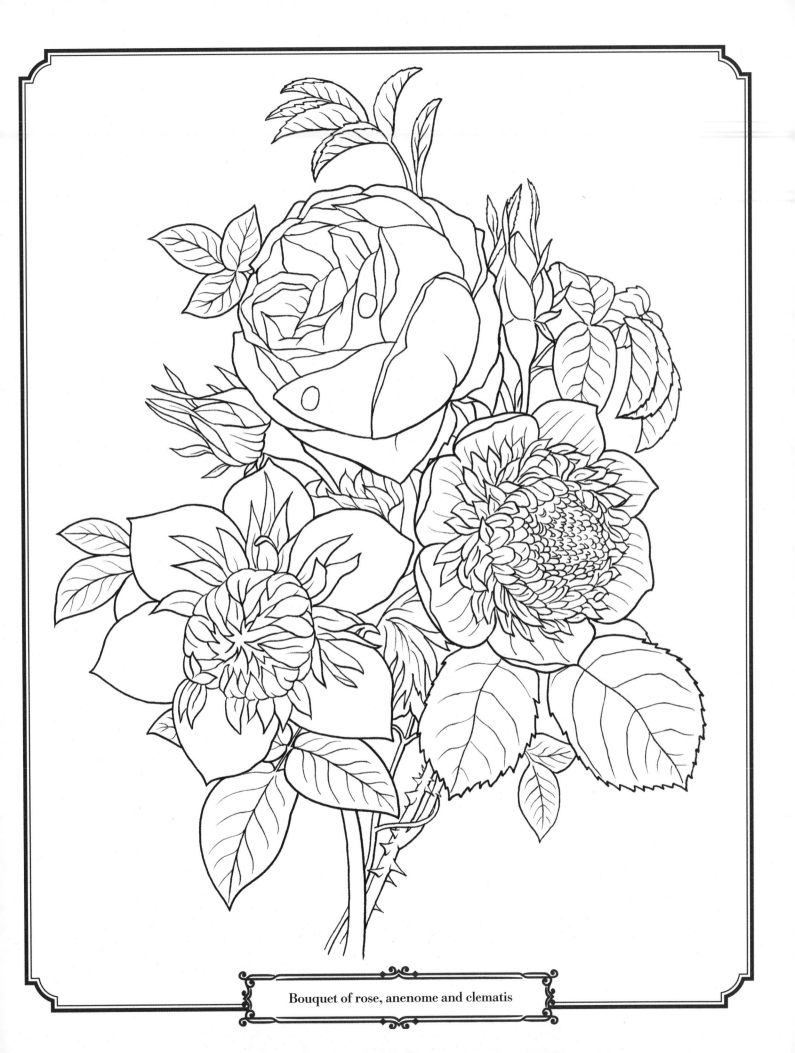

Bouquet of rose, anenome and clematis

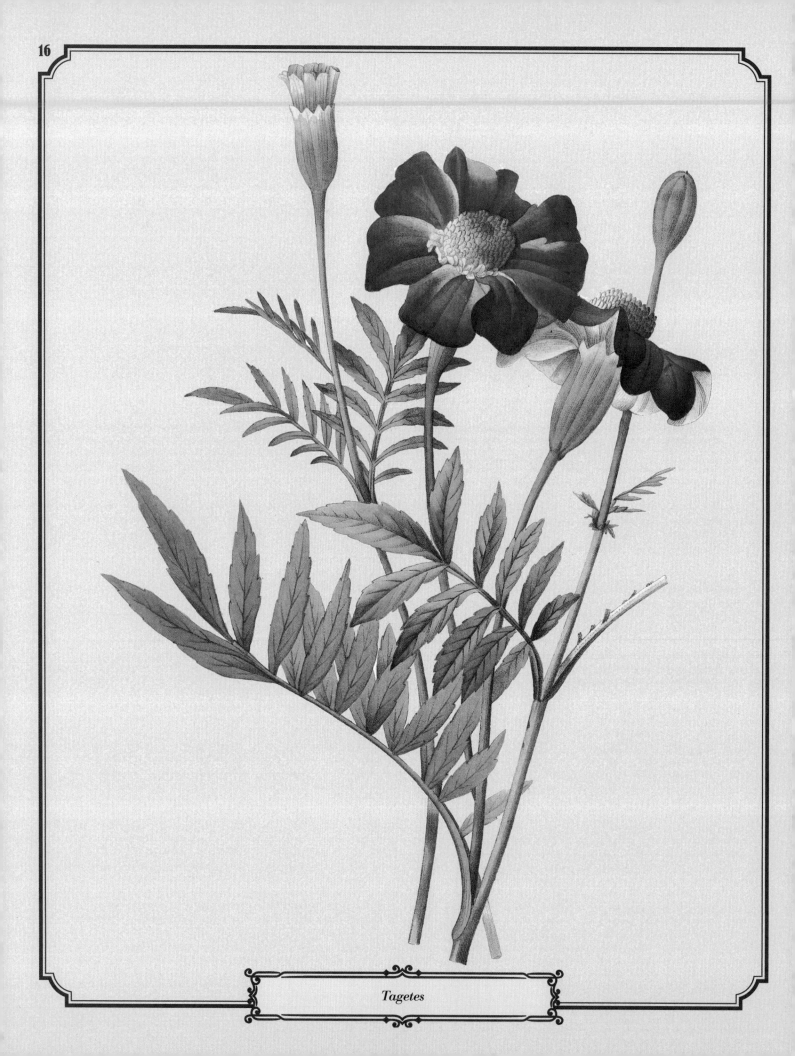

Tagetes

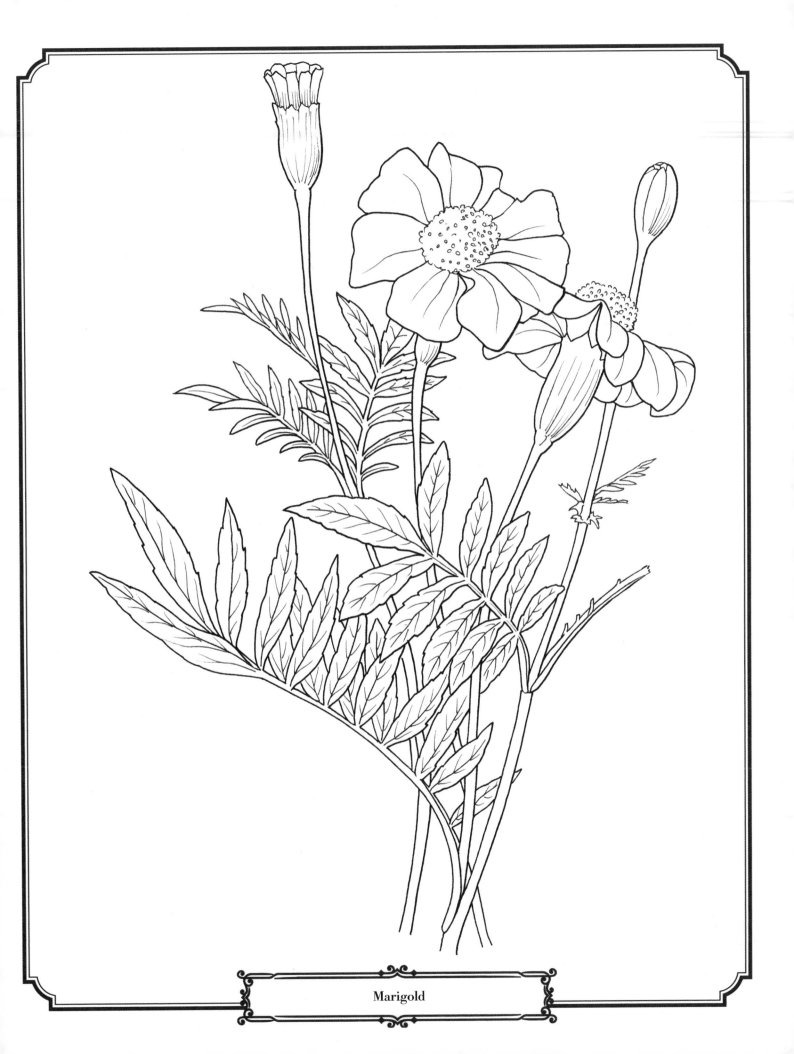

Marigold

Dianthus albo-nigricans

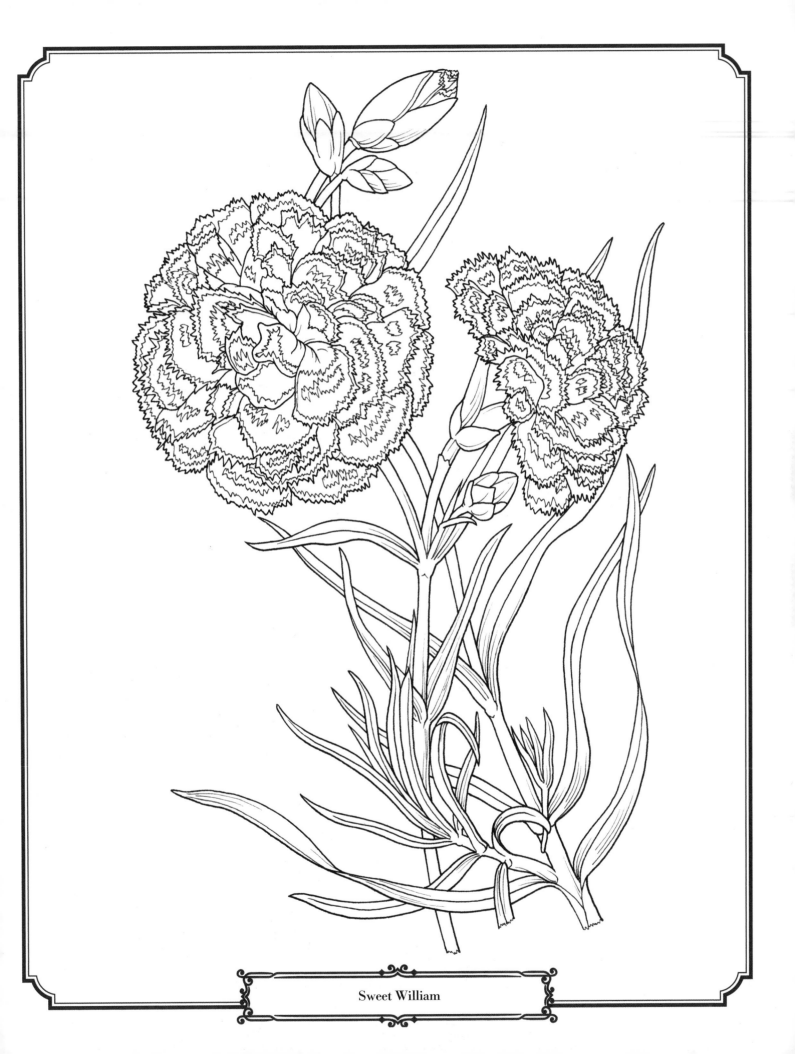

Sweet William

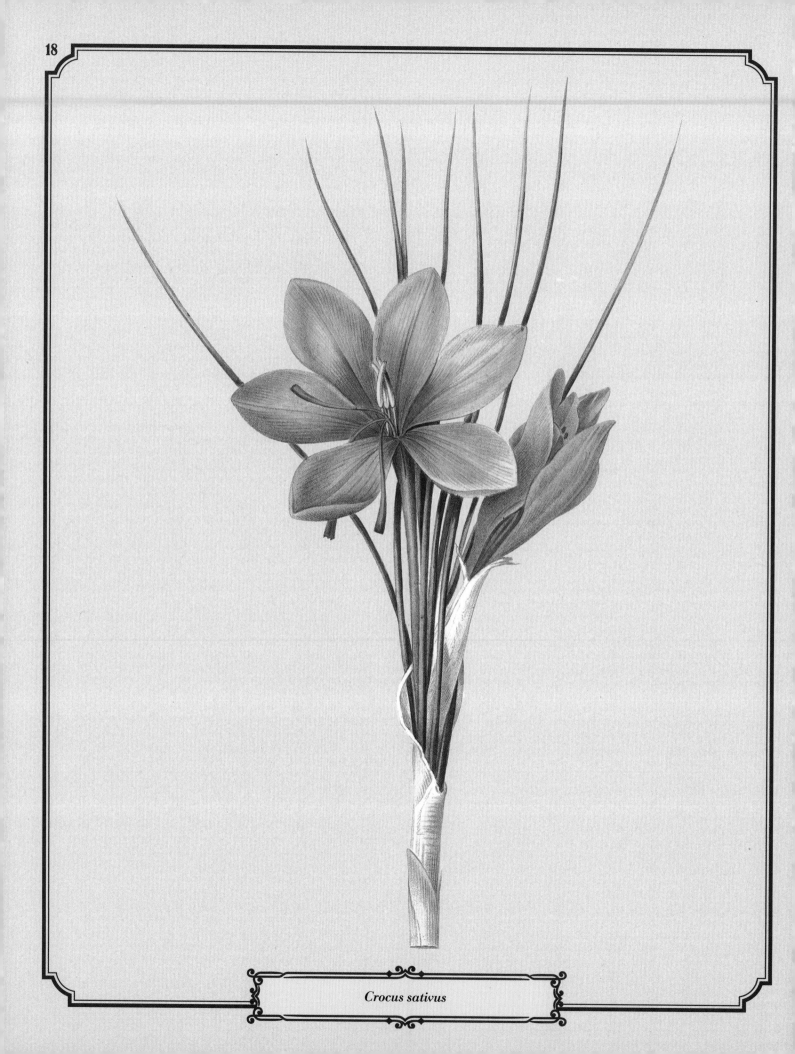

Crocus sativus

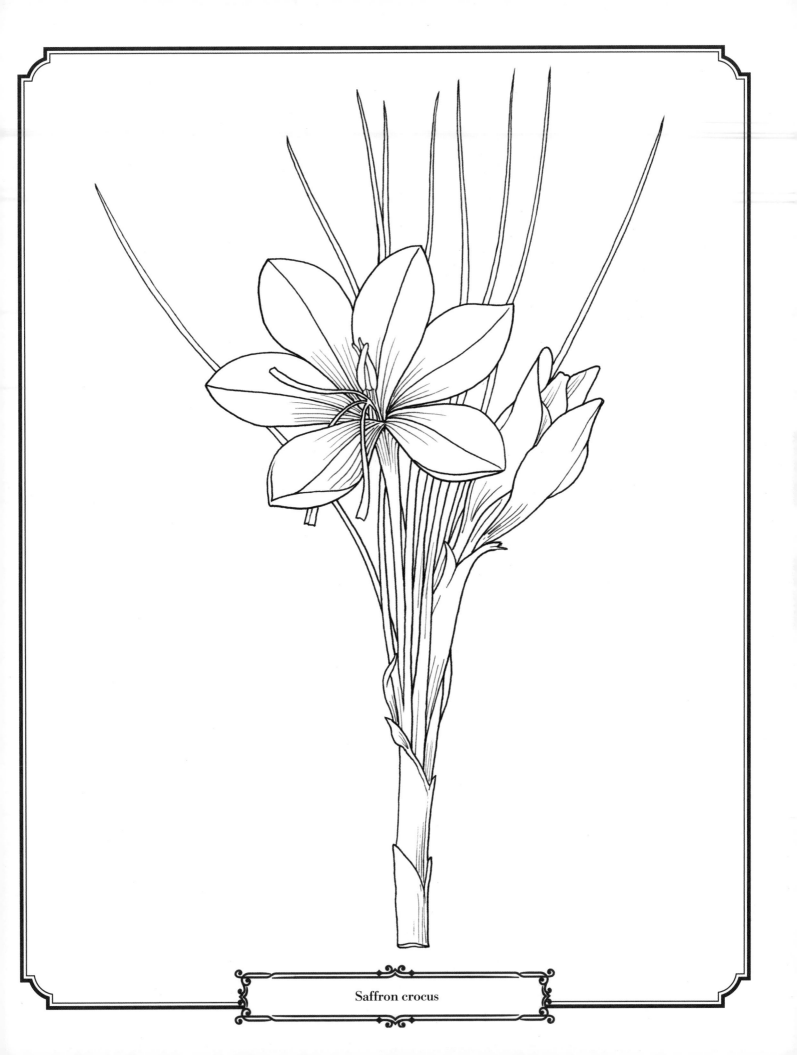

Saffron crocus

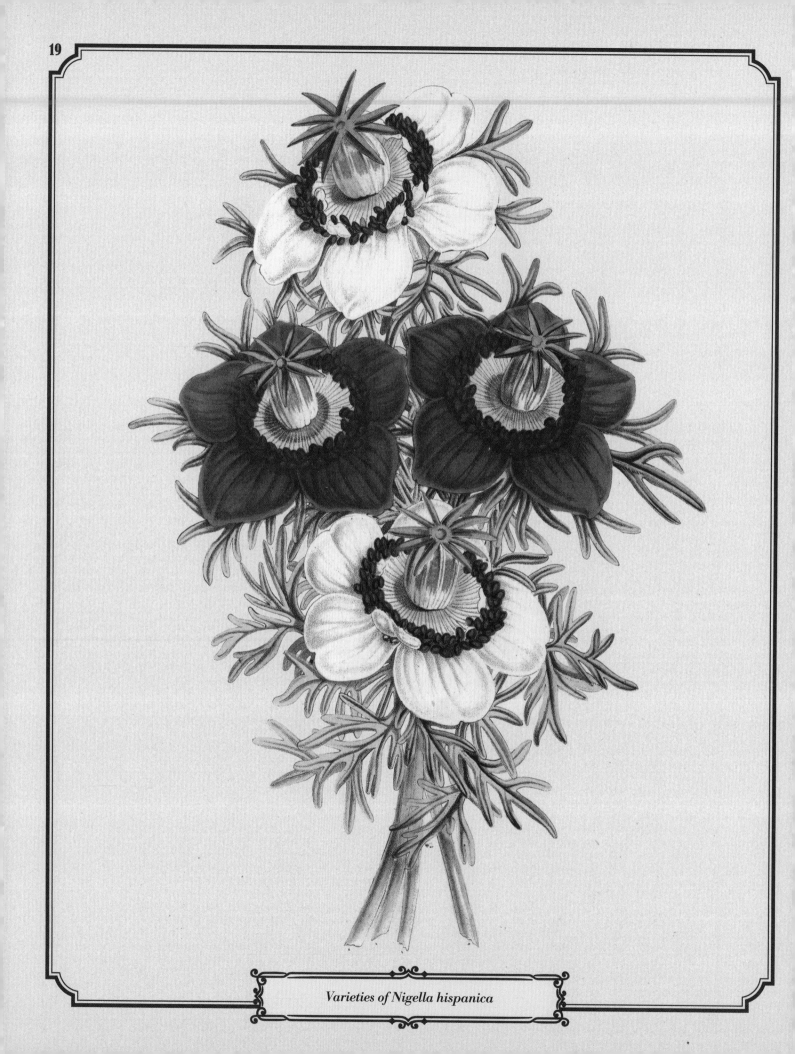

Varieties of Nigella hispanica

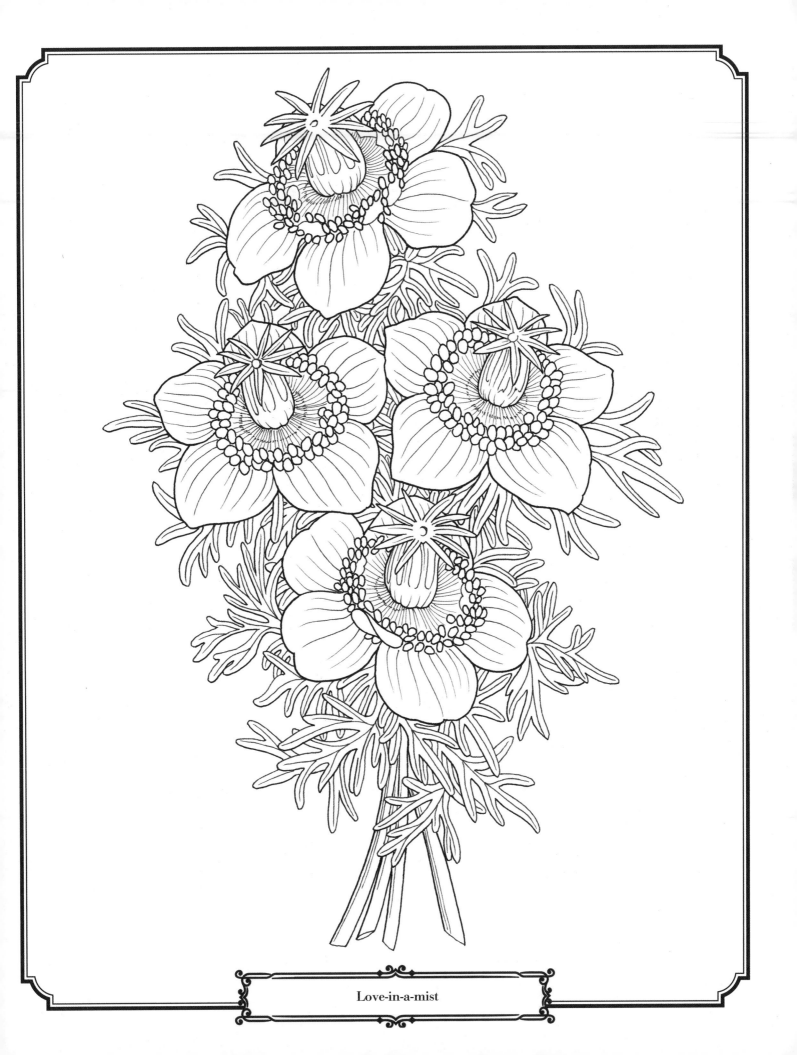

Love-in-a-mist

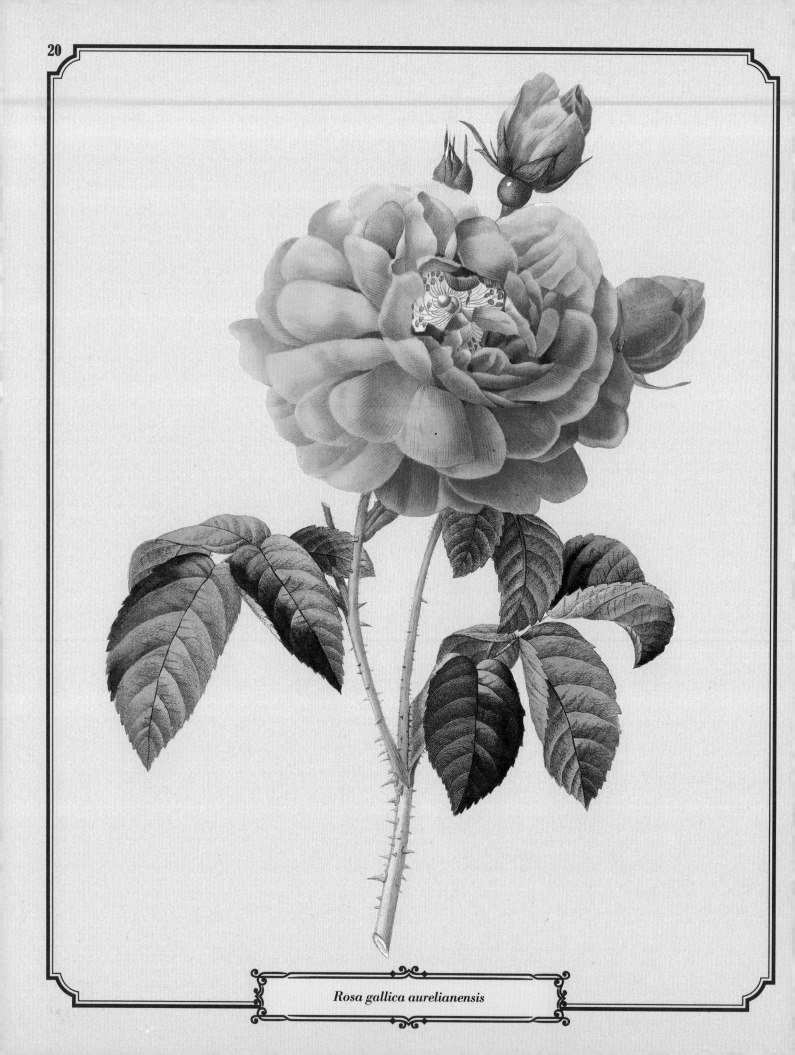

Rosa gallica aurelianensis

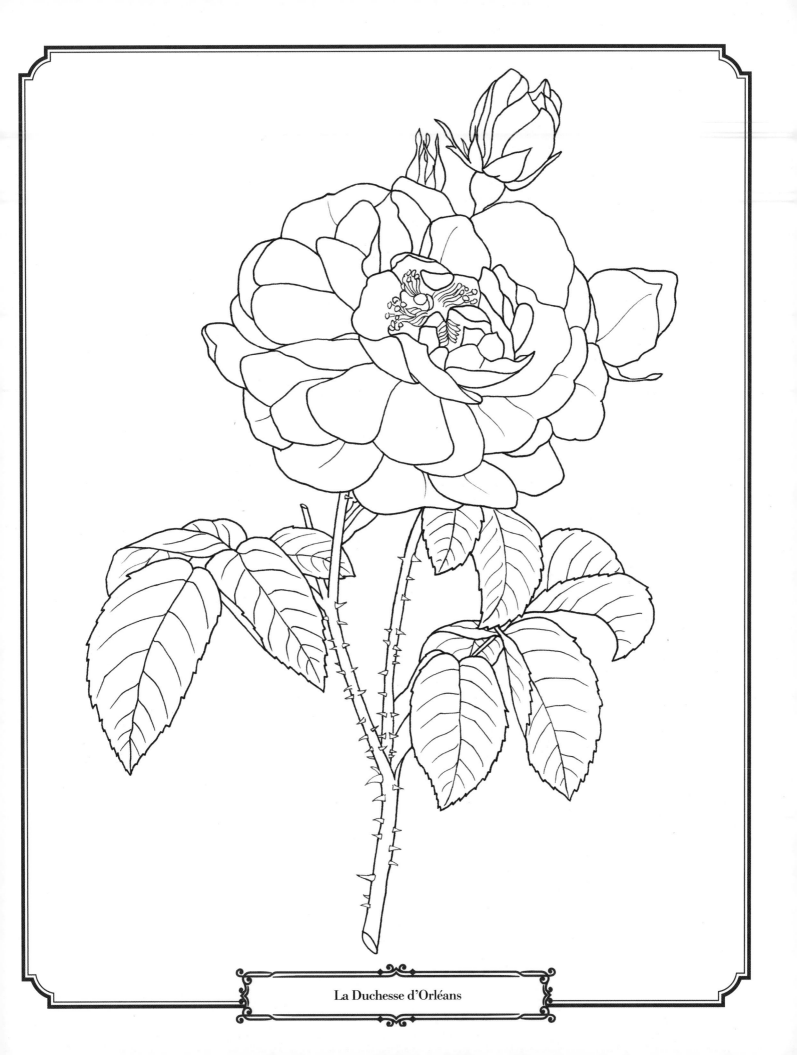

La Duchesse d'Orléans

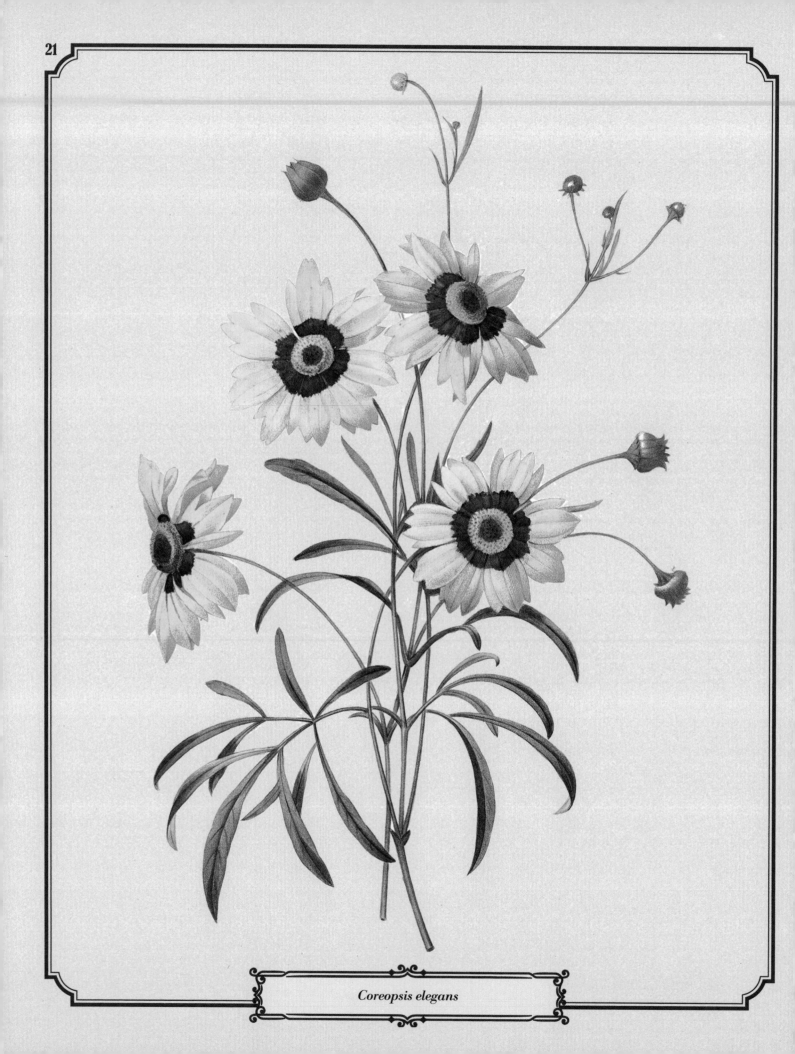

Coreopsis elegans

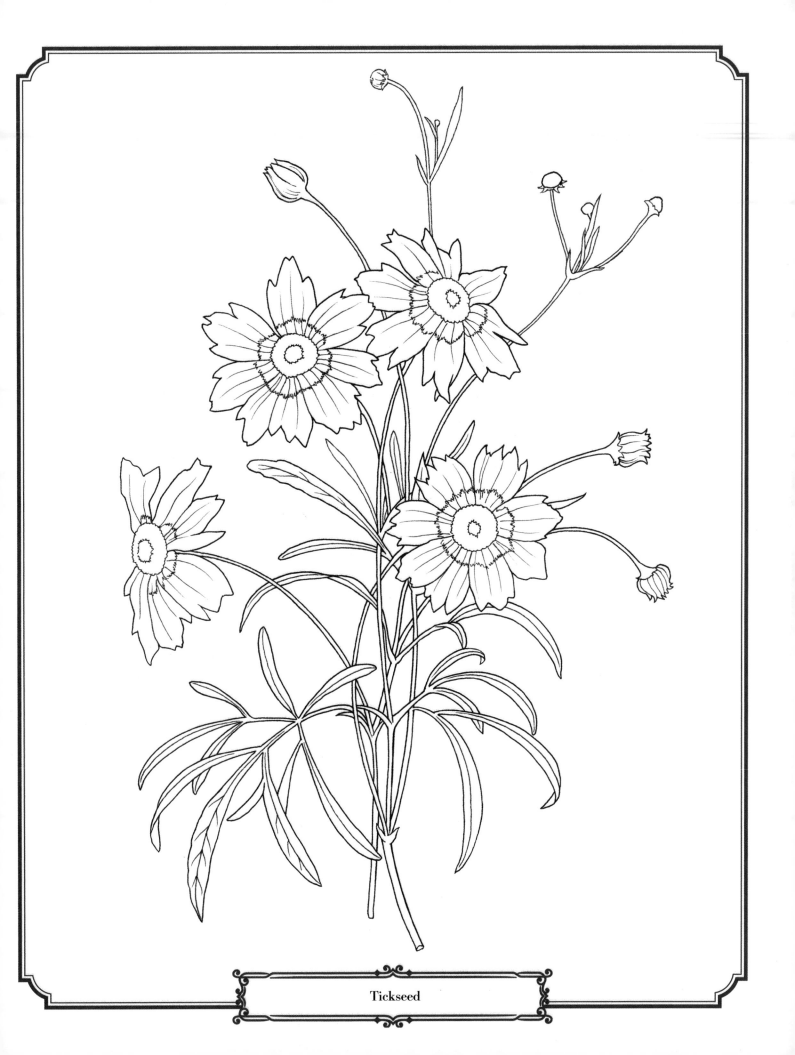

Tickseed

Aquilegia spectabilis

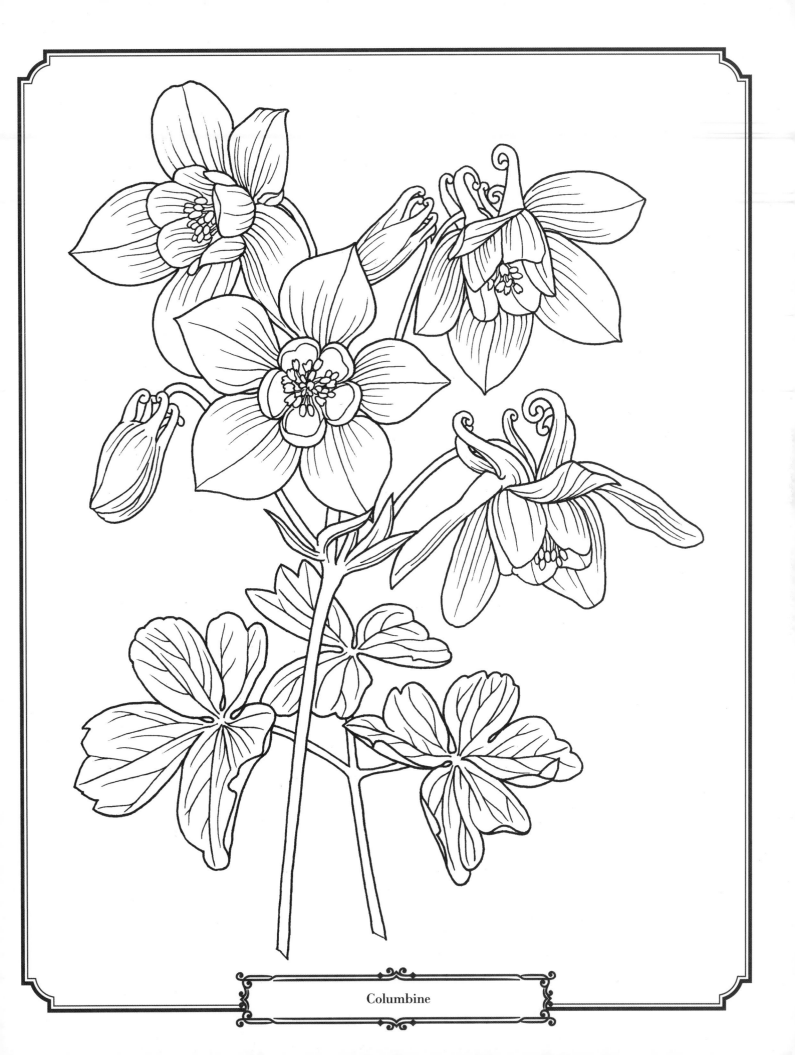

Columbine

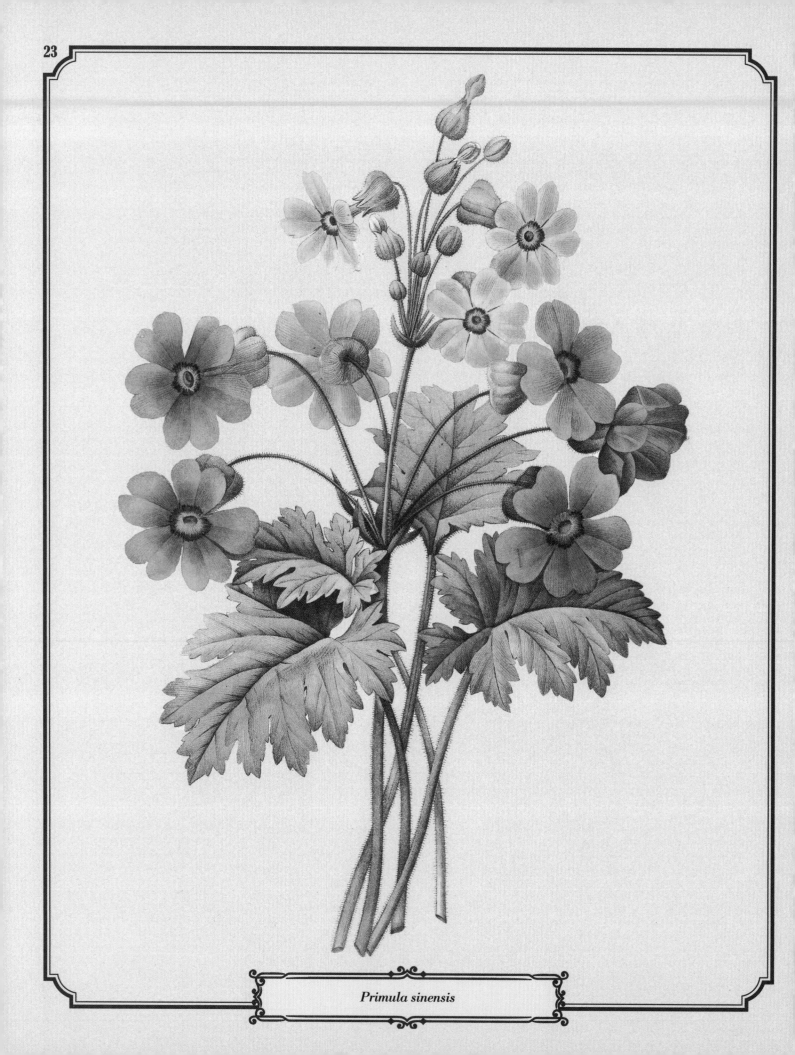

Primula sinensis

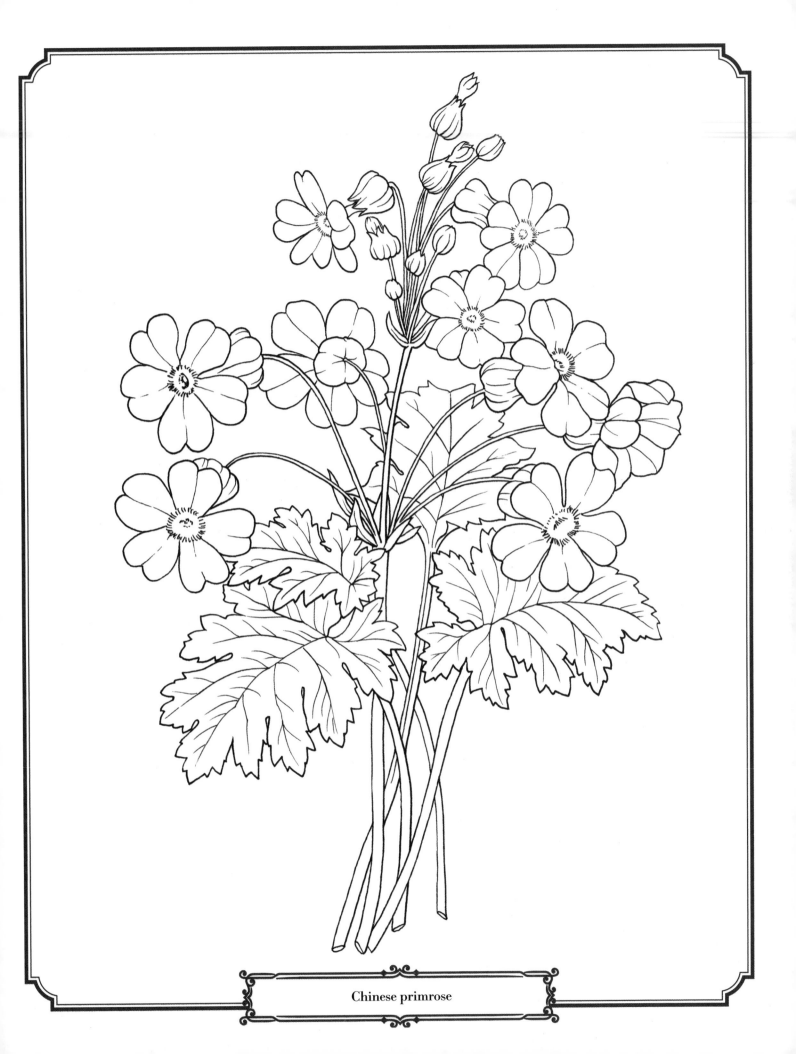

Chinese primrose

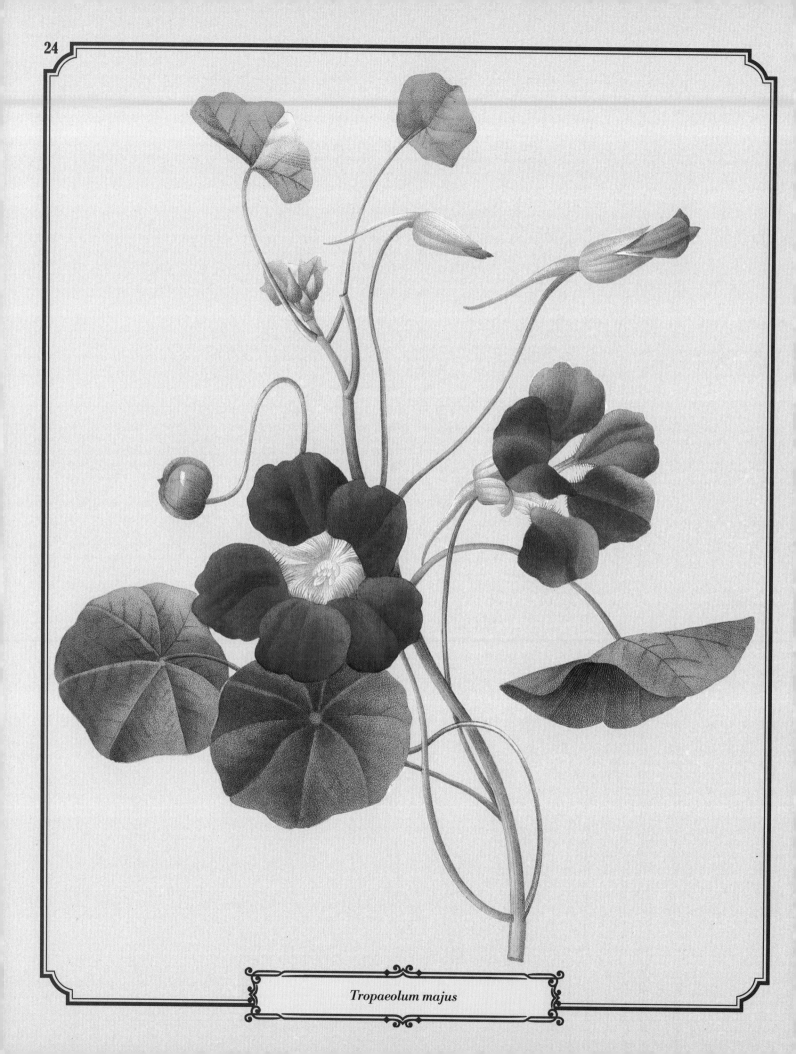

Tropaeolum majus

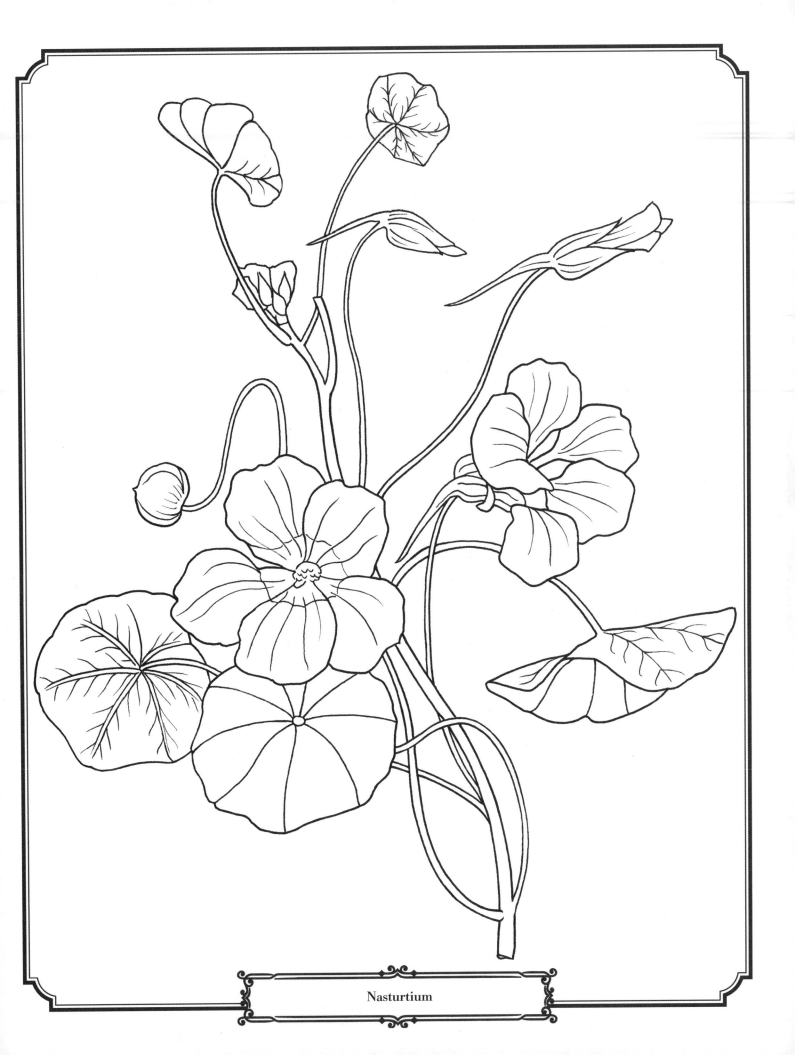

Nasturtium

Azalea indica gigantiflora

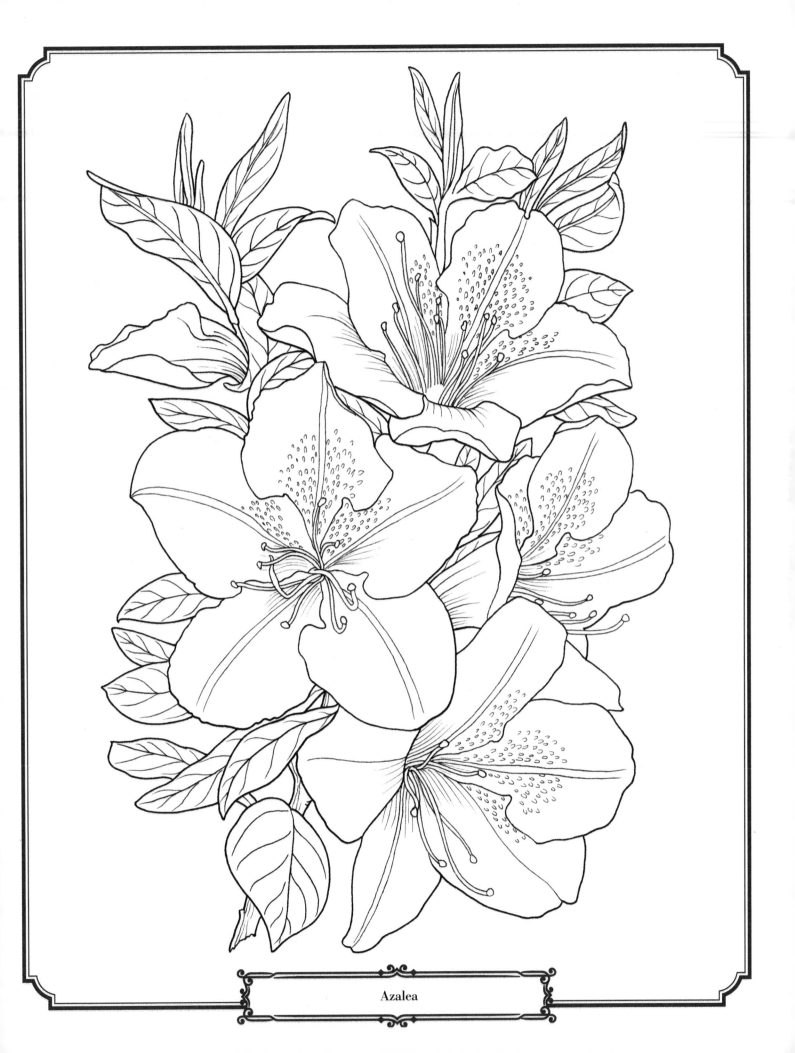

Azalea

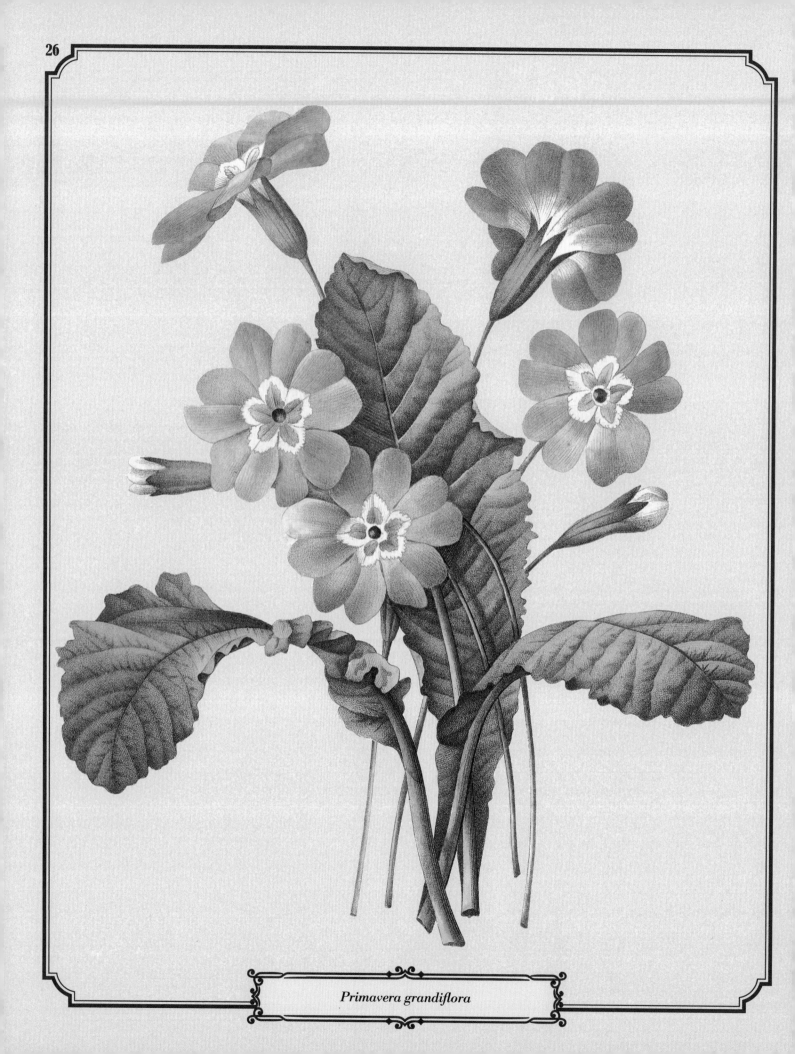

Primavera grandiflora

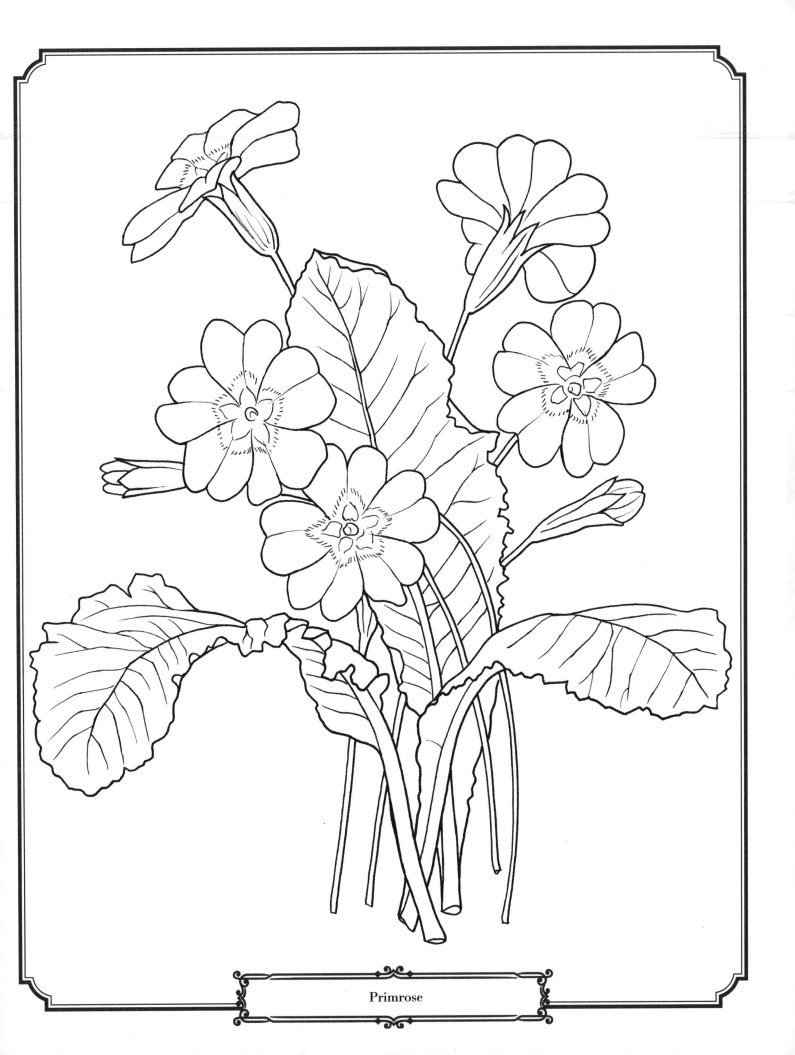

Primrose

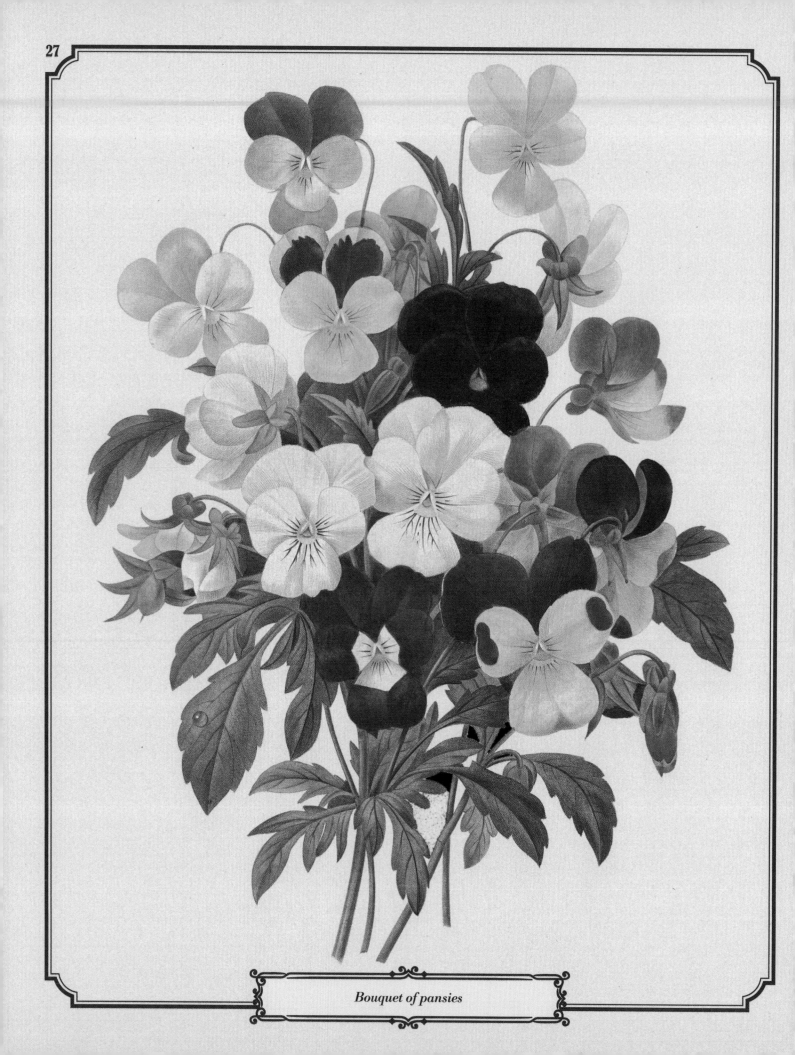

Bouquet of pansies

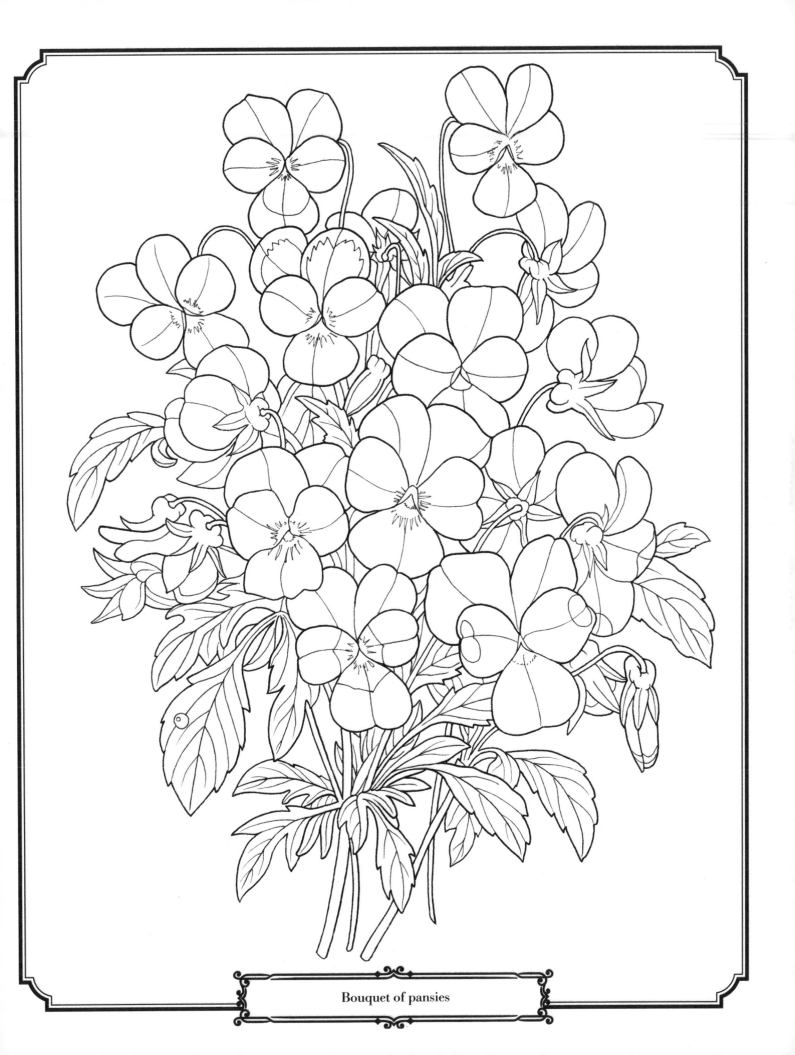

Bouquet of pansies

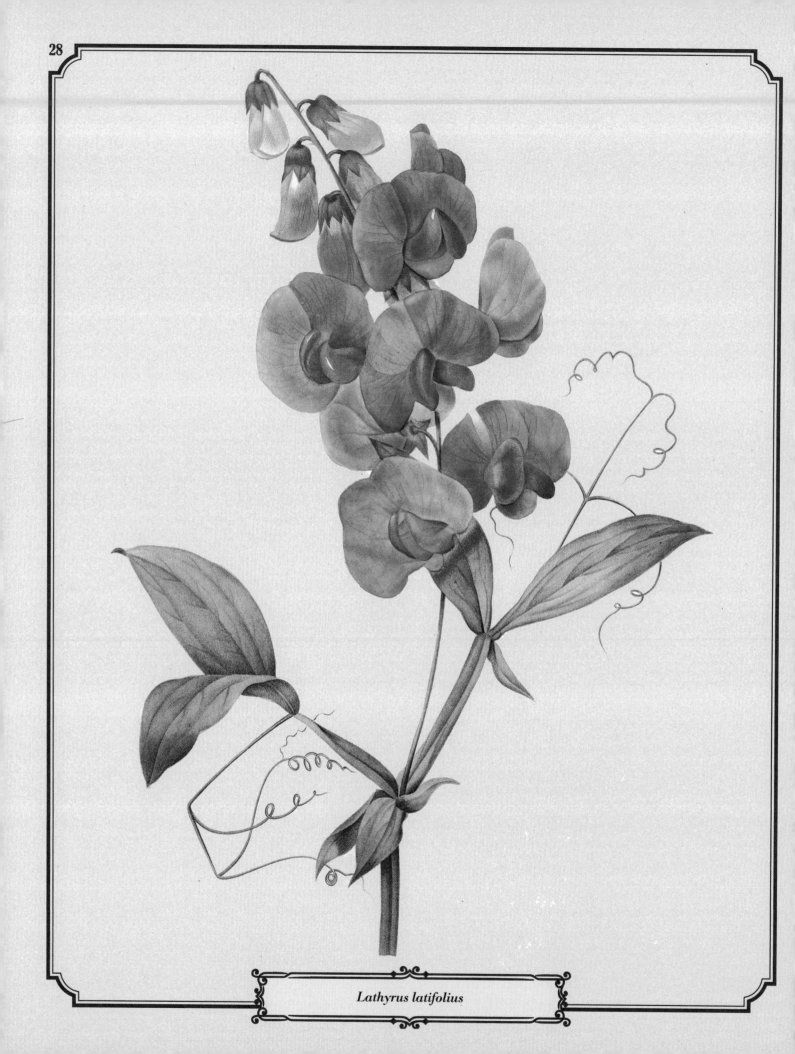

Lathyrus latifolius

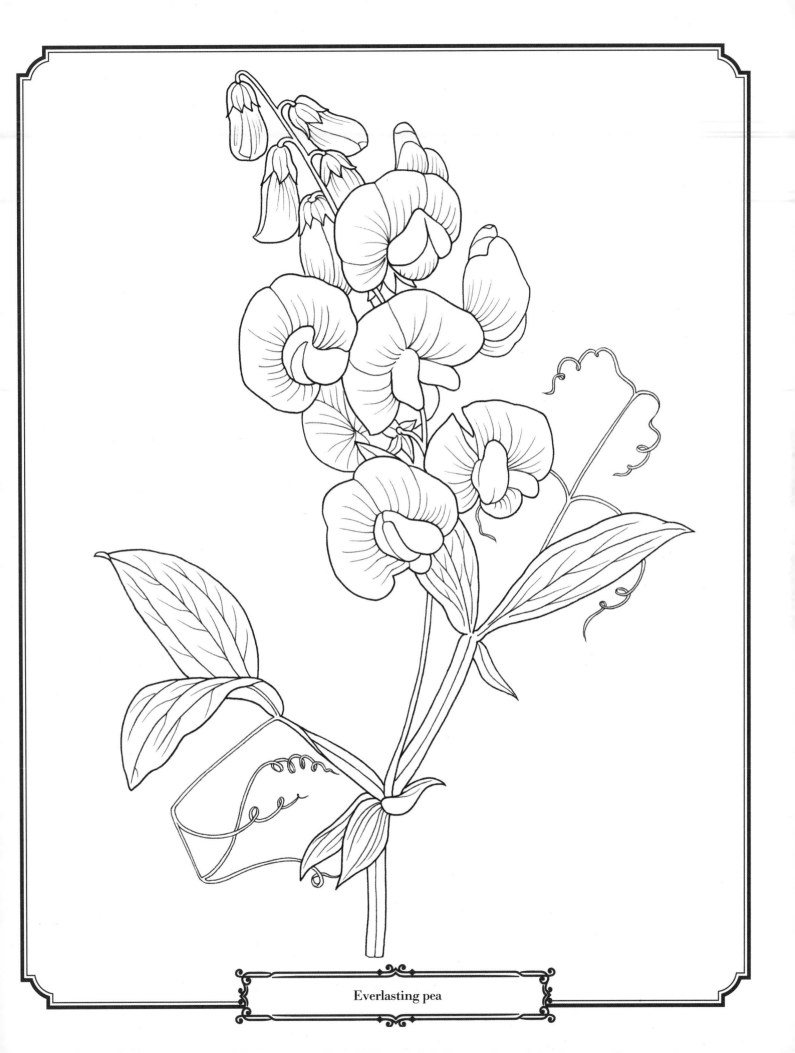

Everlasting pea

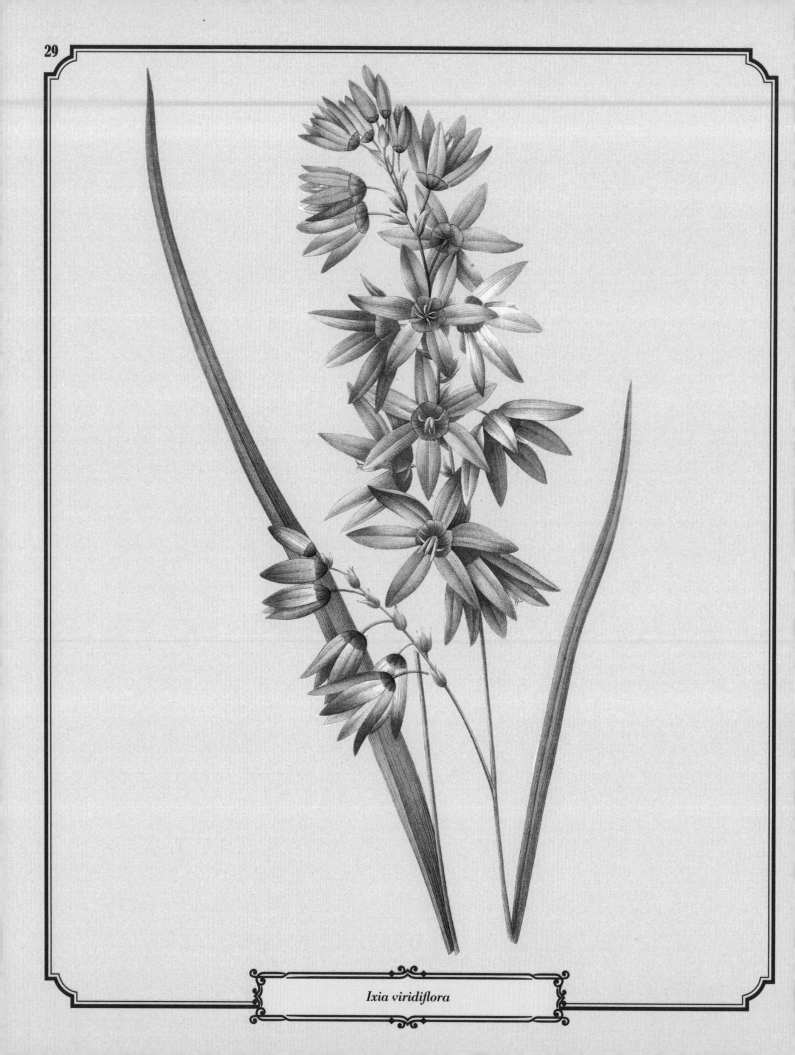

Ixia viridiflora

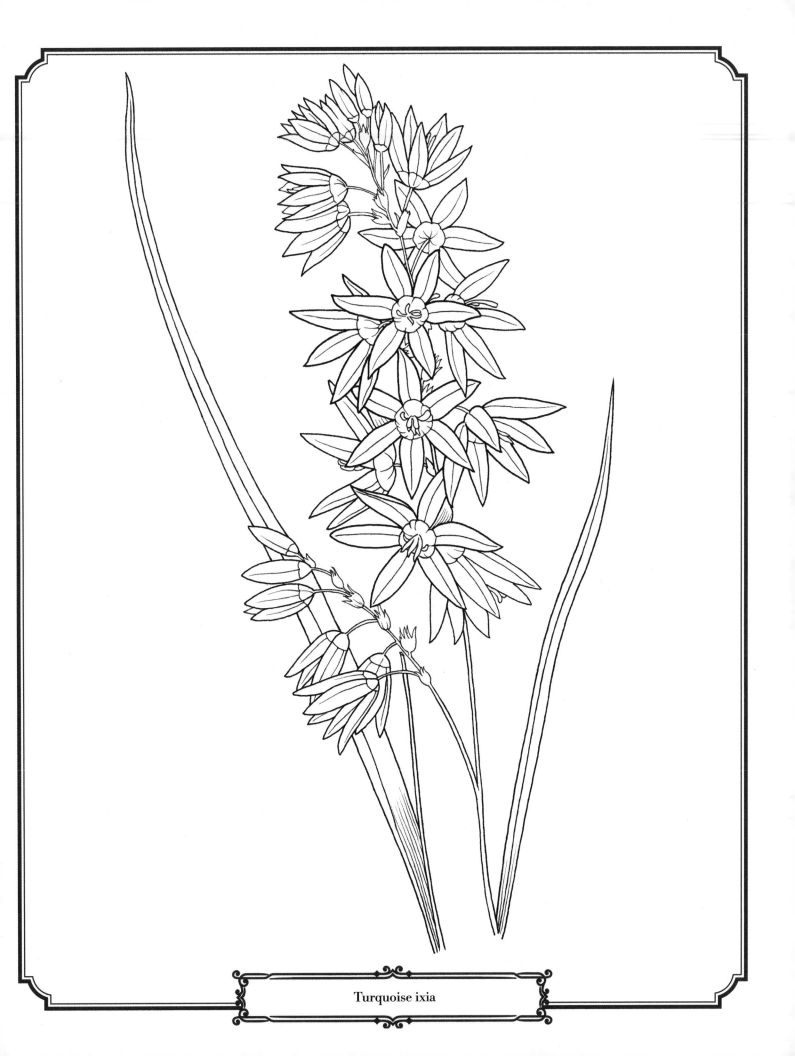

Turquoise ixia

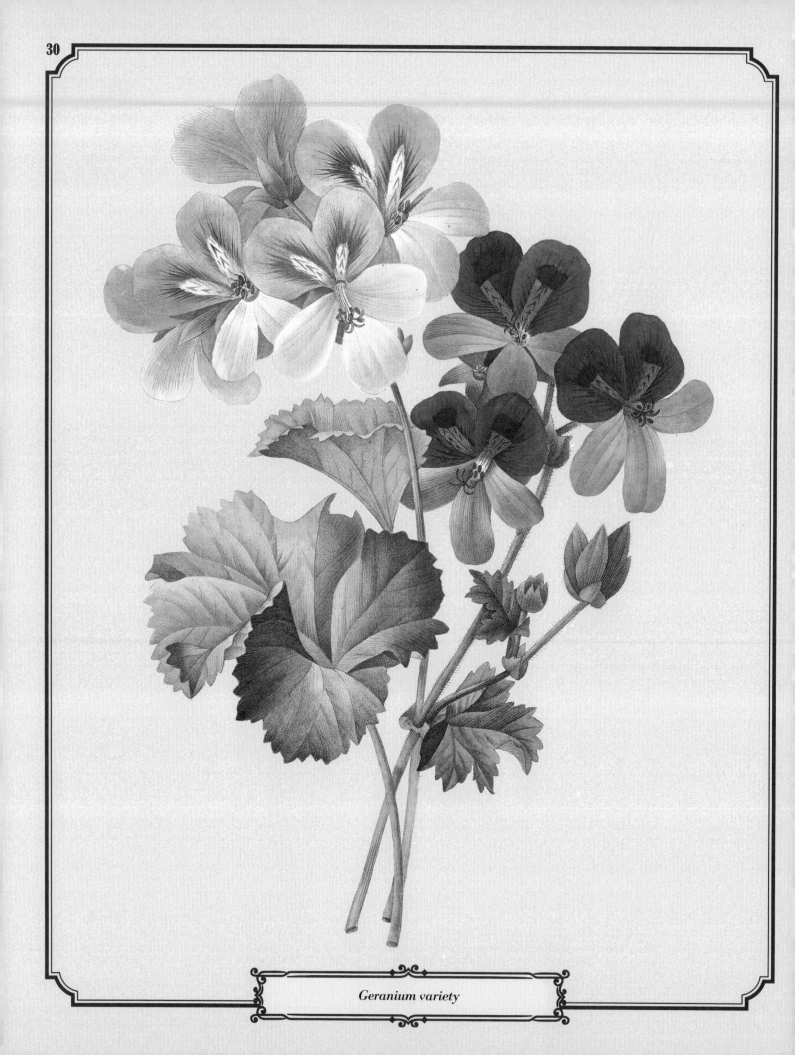

Geranium variety

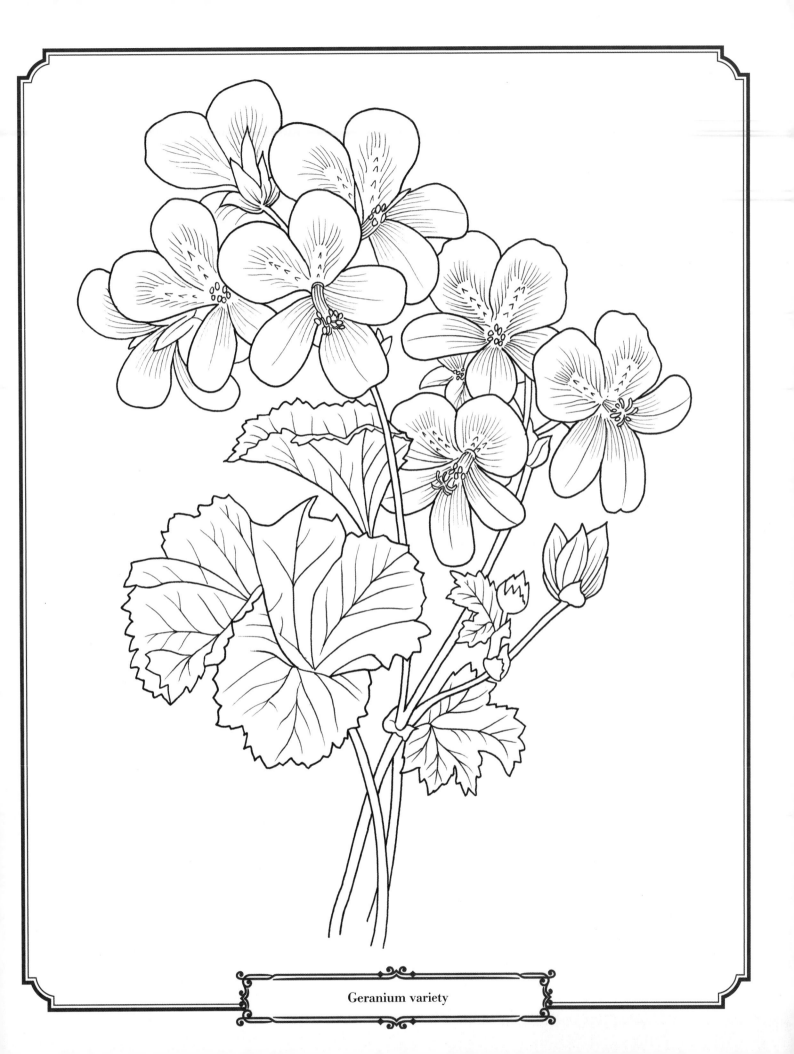

Geranium variety

Petunia inimitabilis

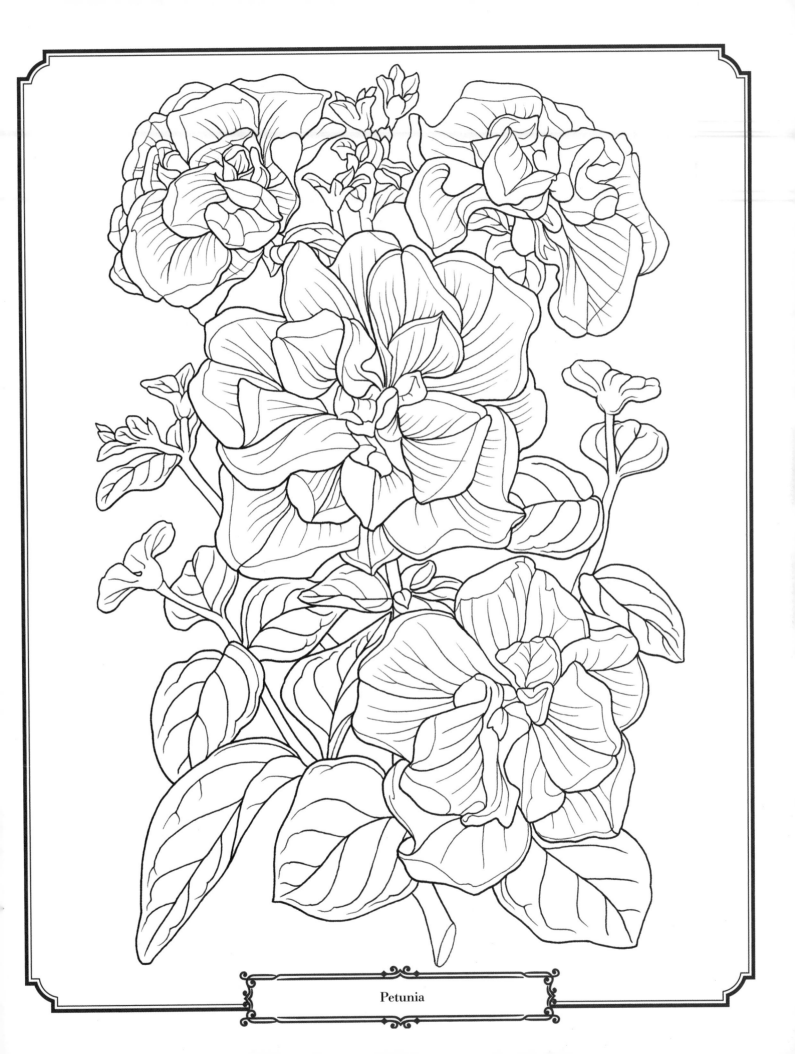

Petunia

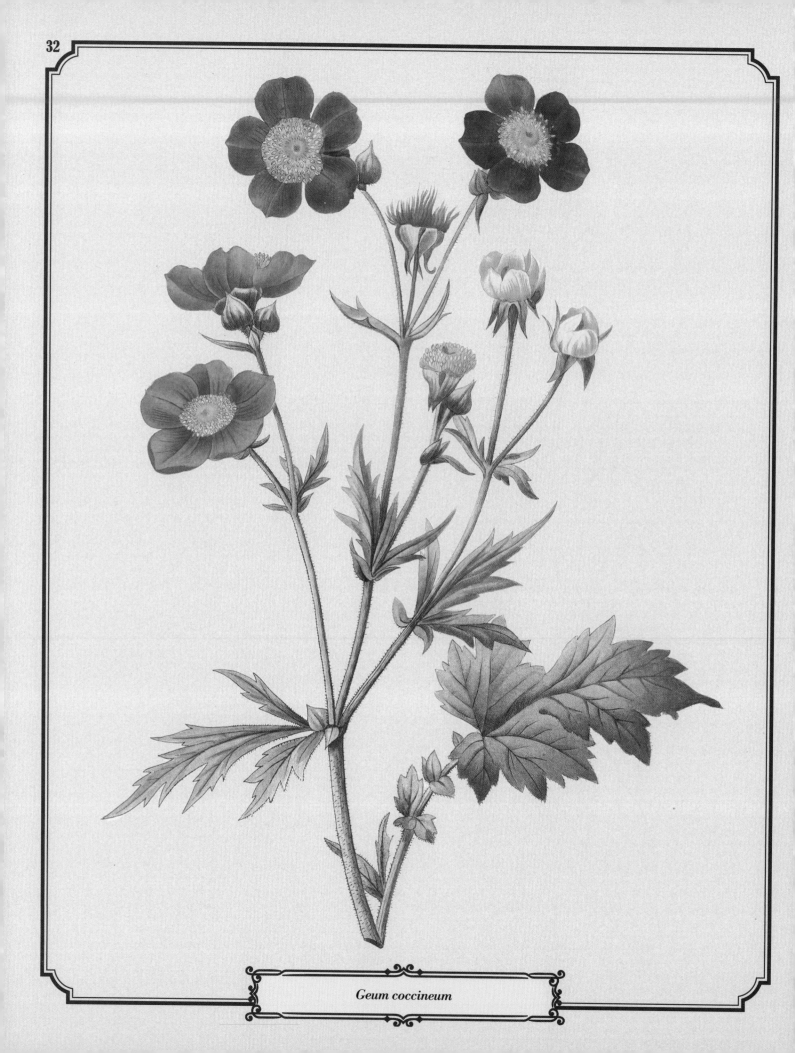

Geum coccineum

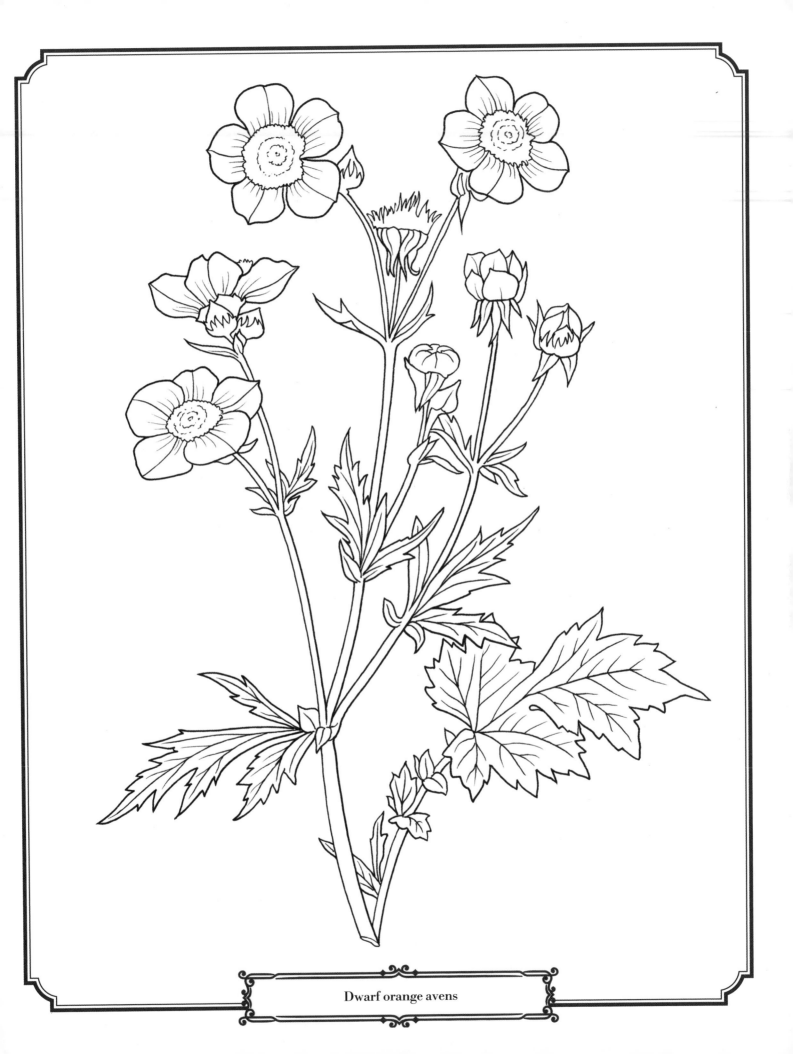

Dwarf orange avens

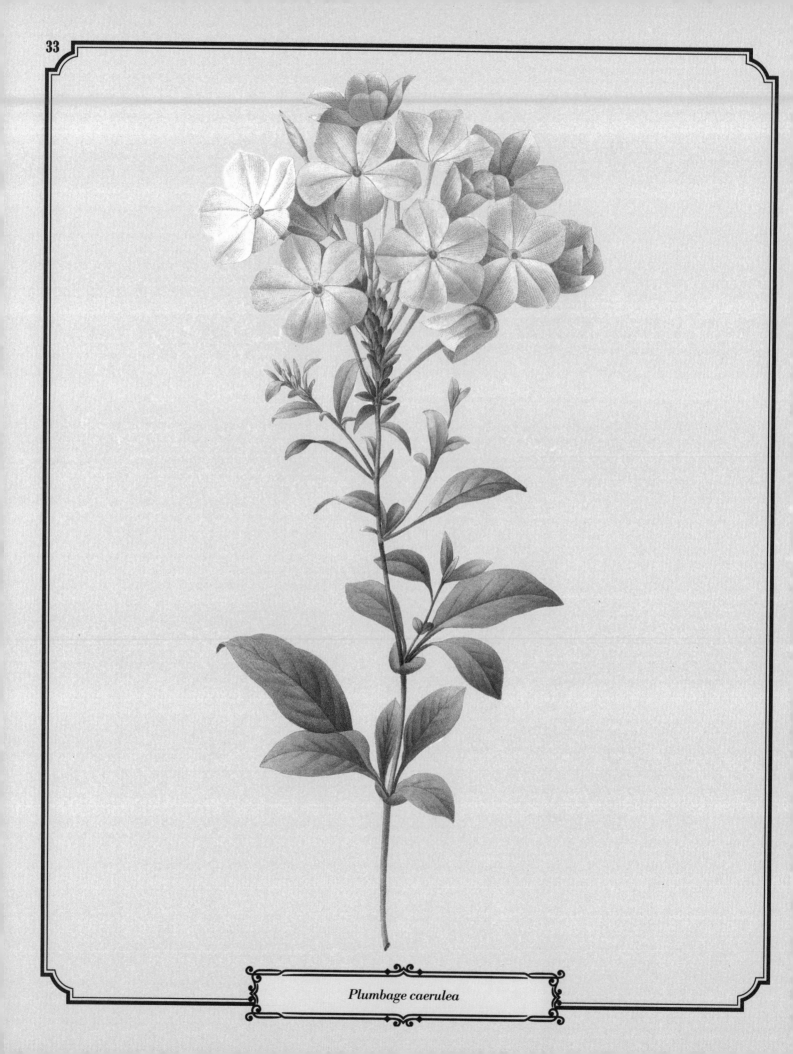

Plumbage caerulea

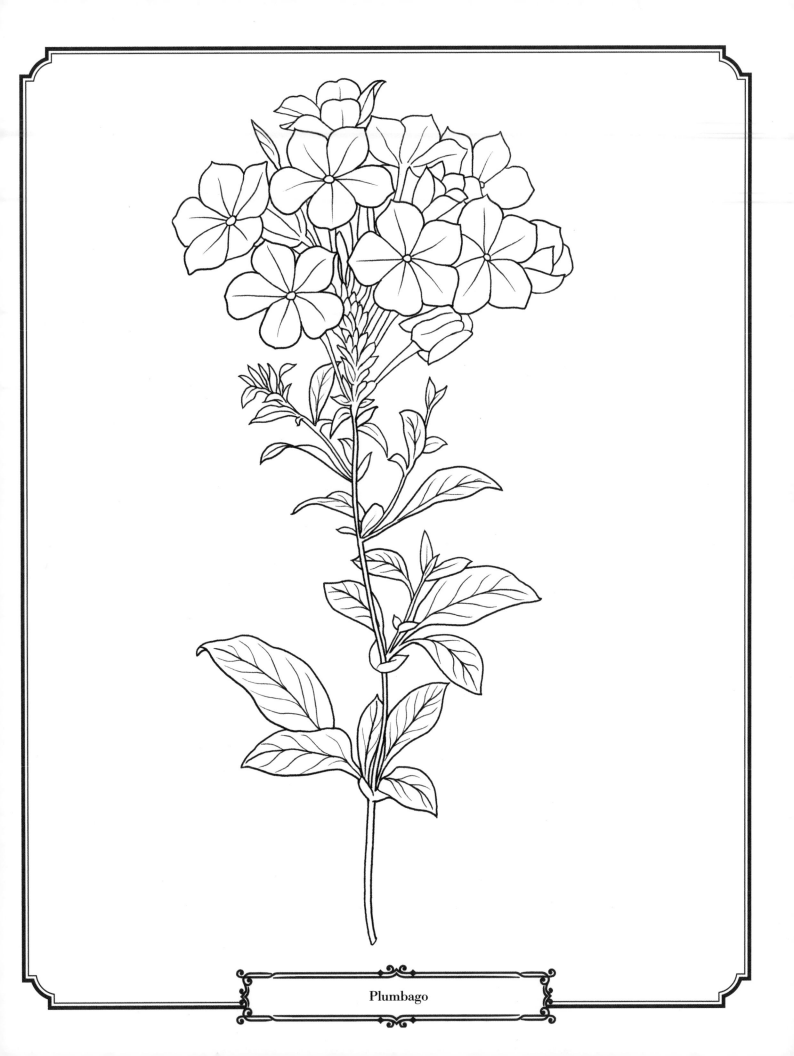

Plumbago

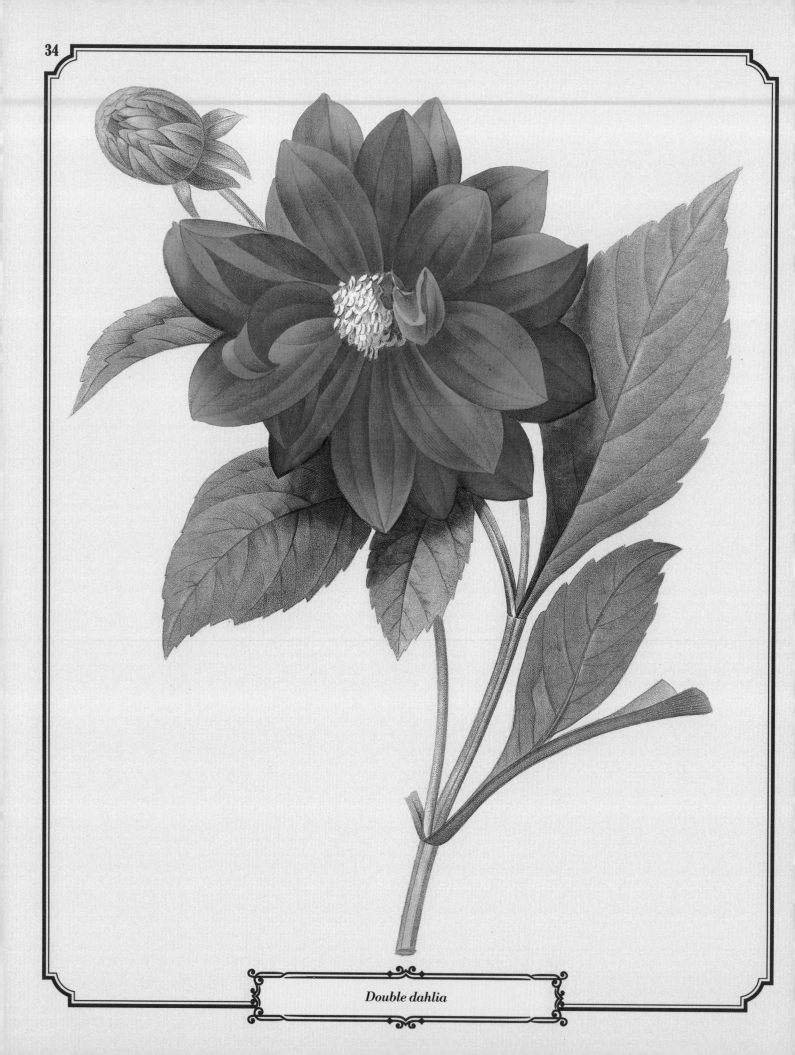

Double dahlia

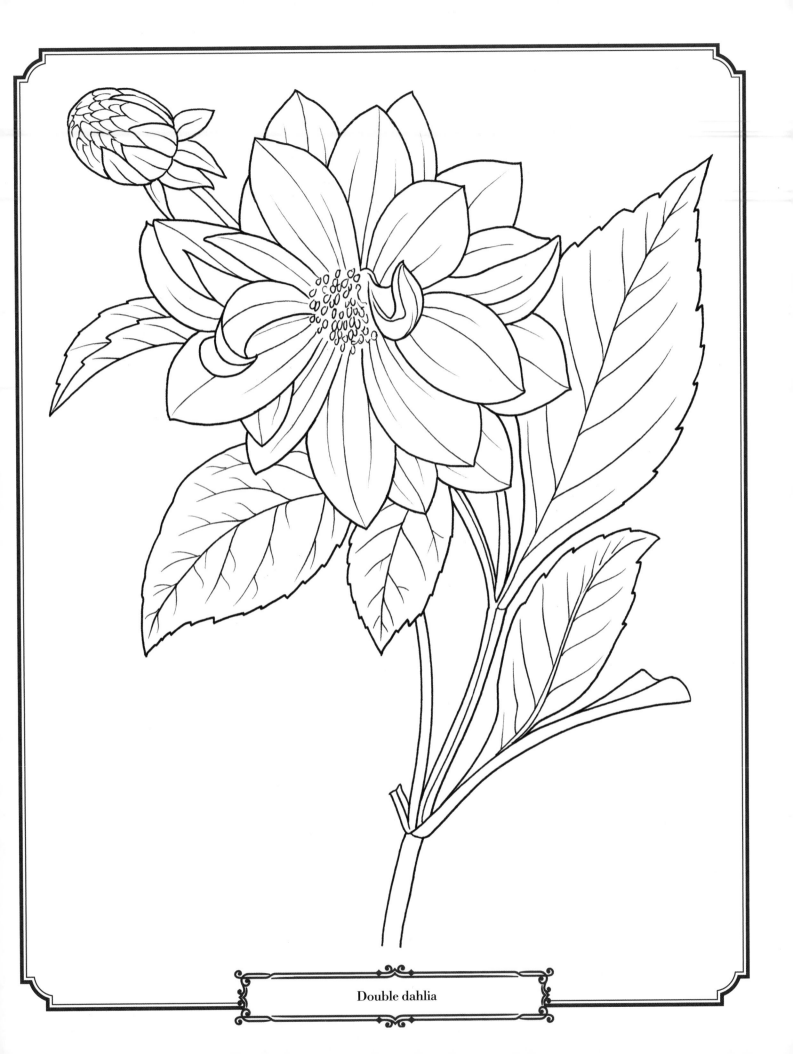

Double dahlia

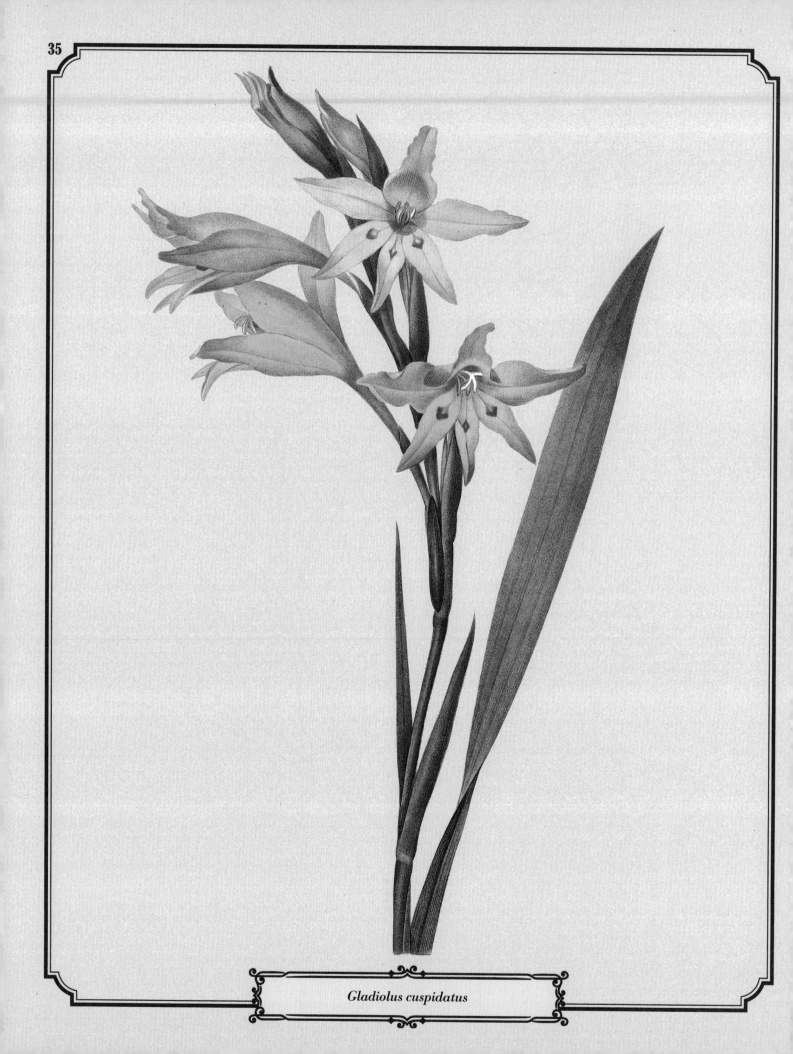

Gladiolus cuspidatus

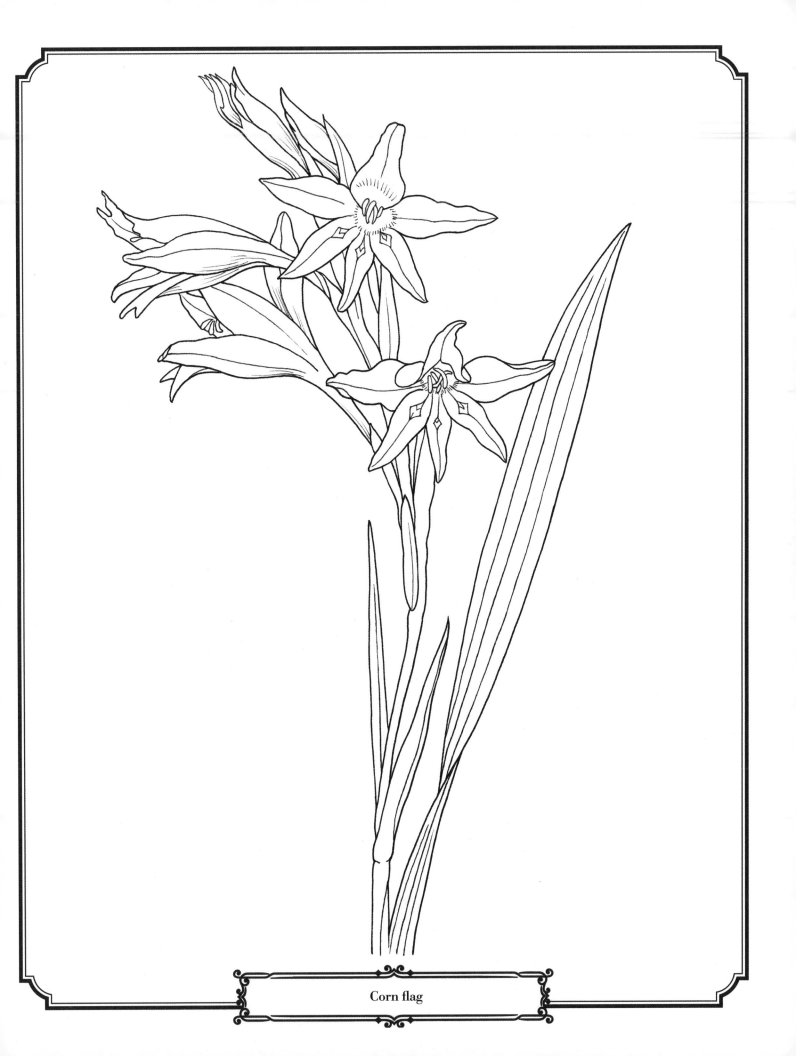

Corn flag

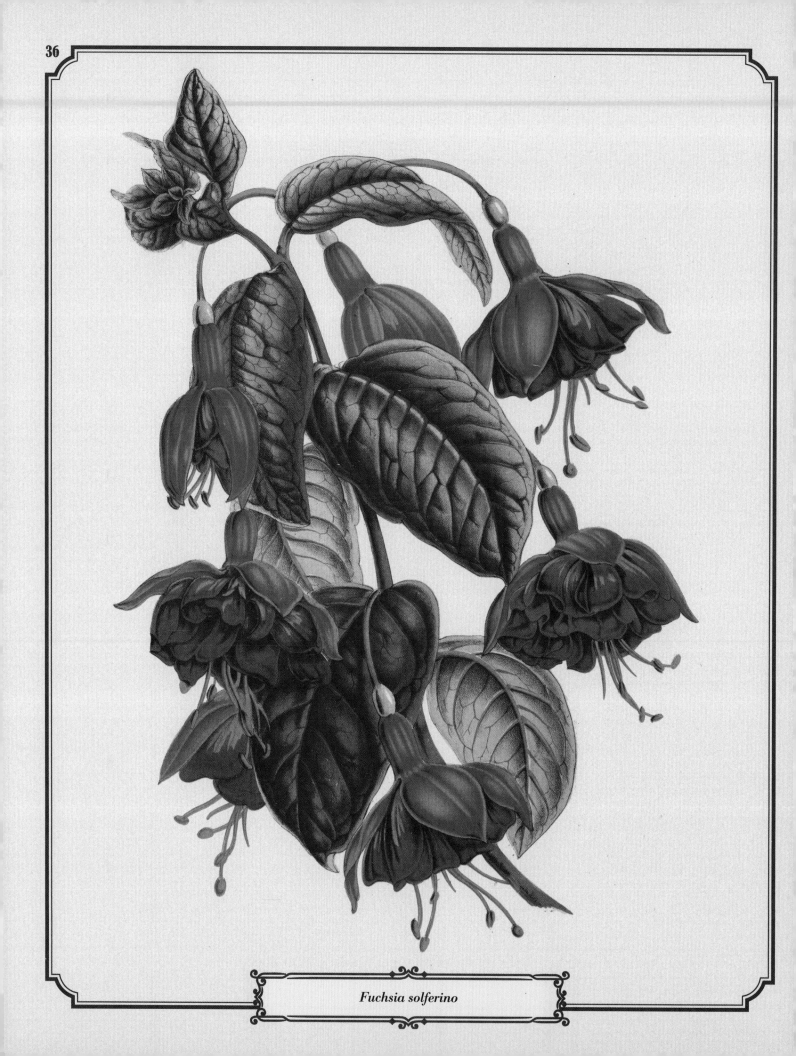

Fuchsia solferino

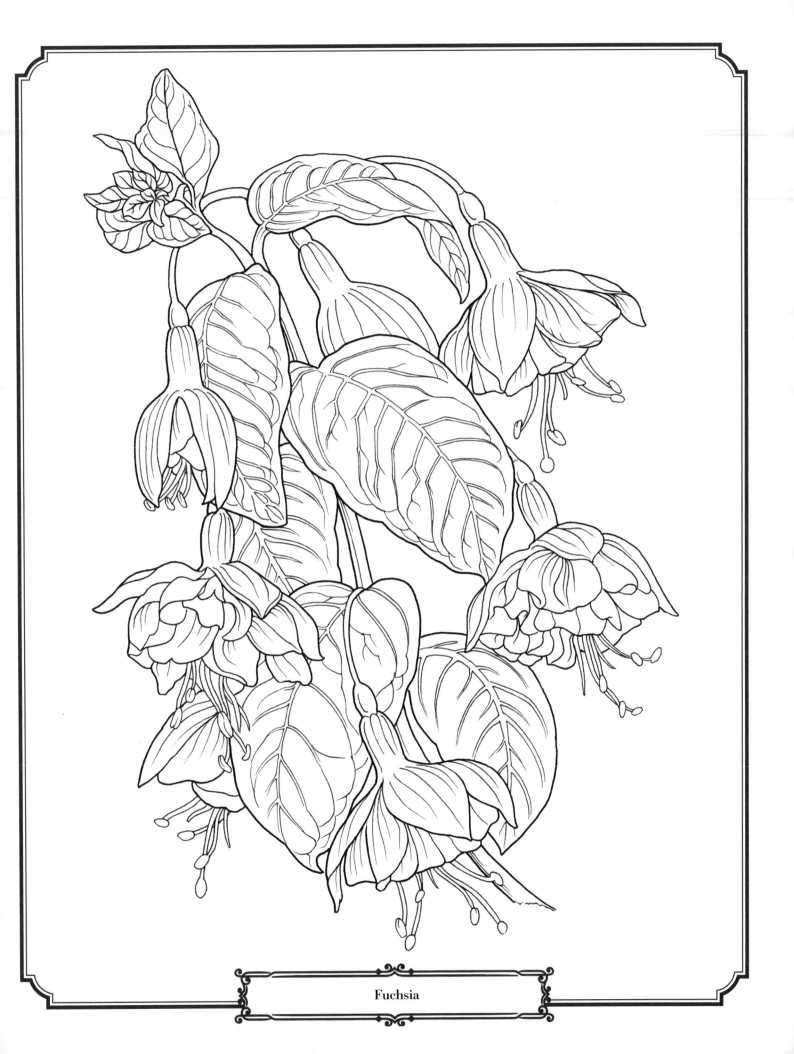

Fuchsia

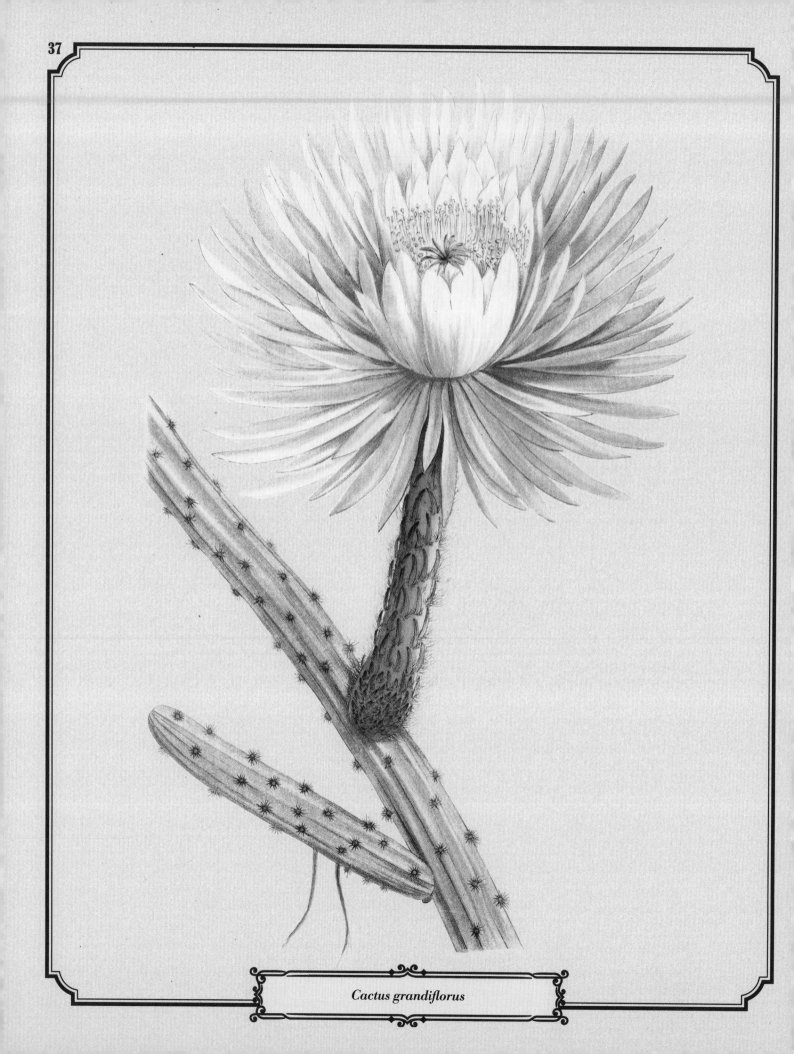

Cactus grandiflorus

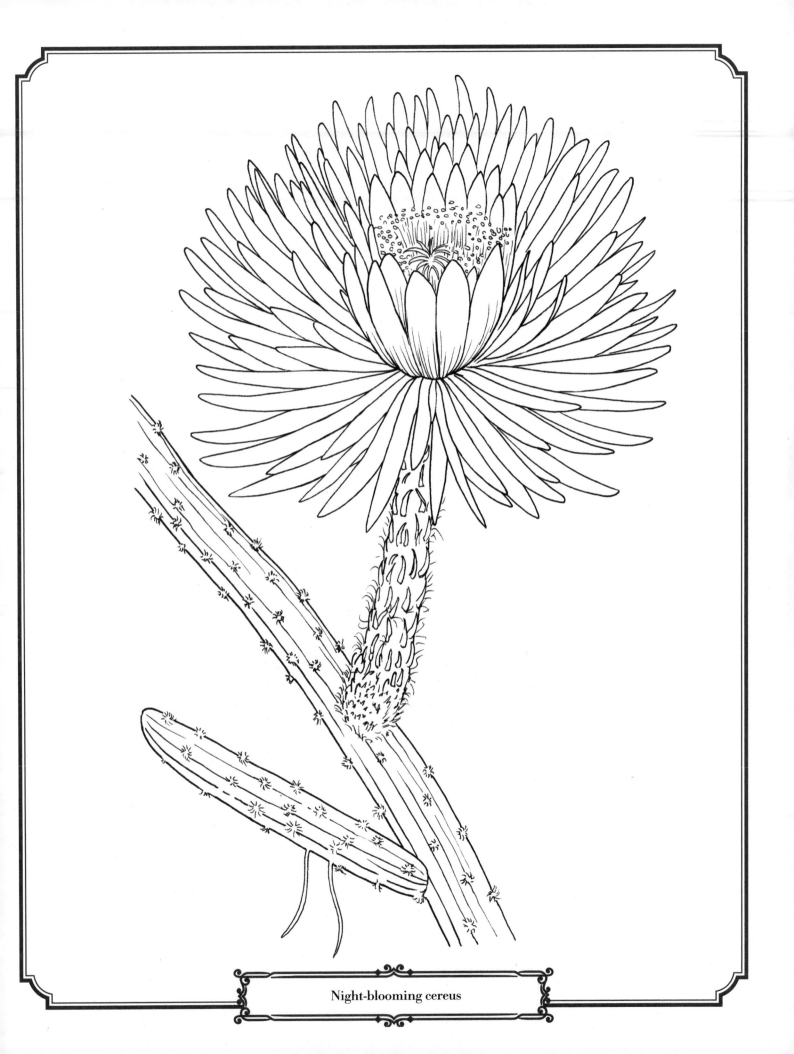

Night-blooming cereus

Rosa pomponia

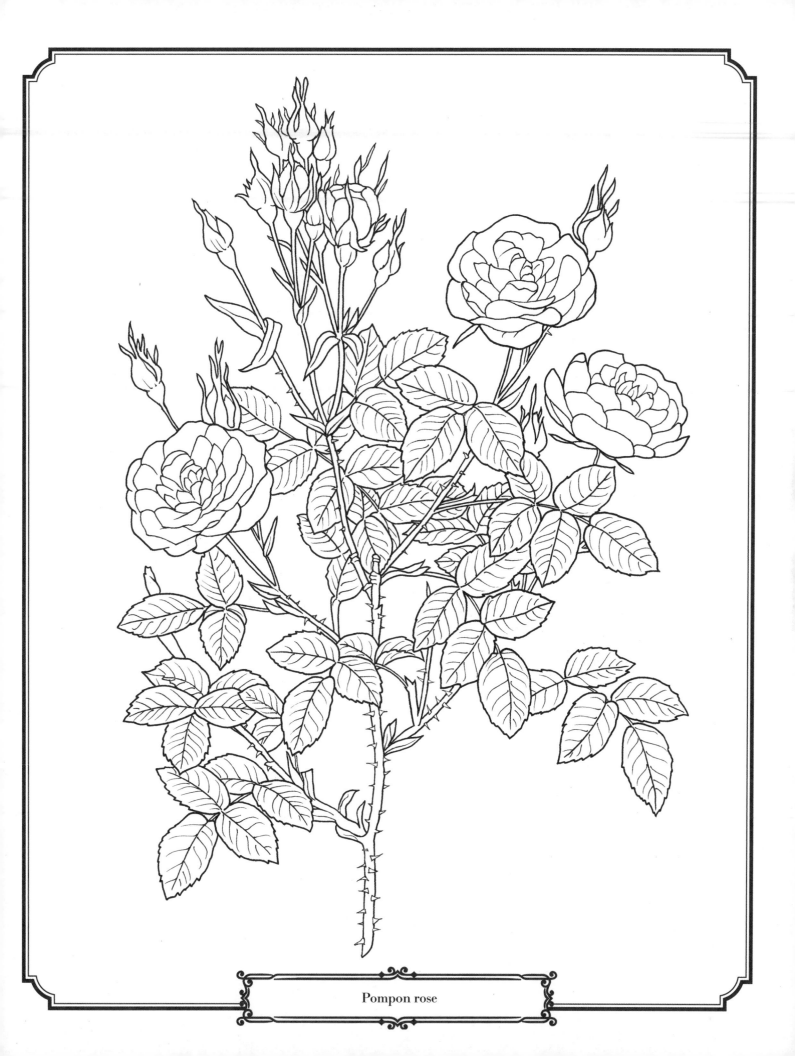

Pompon rose

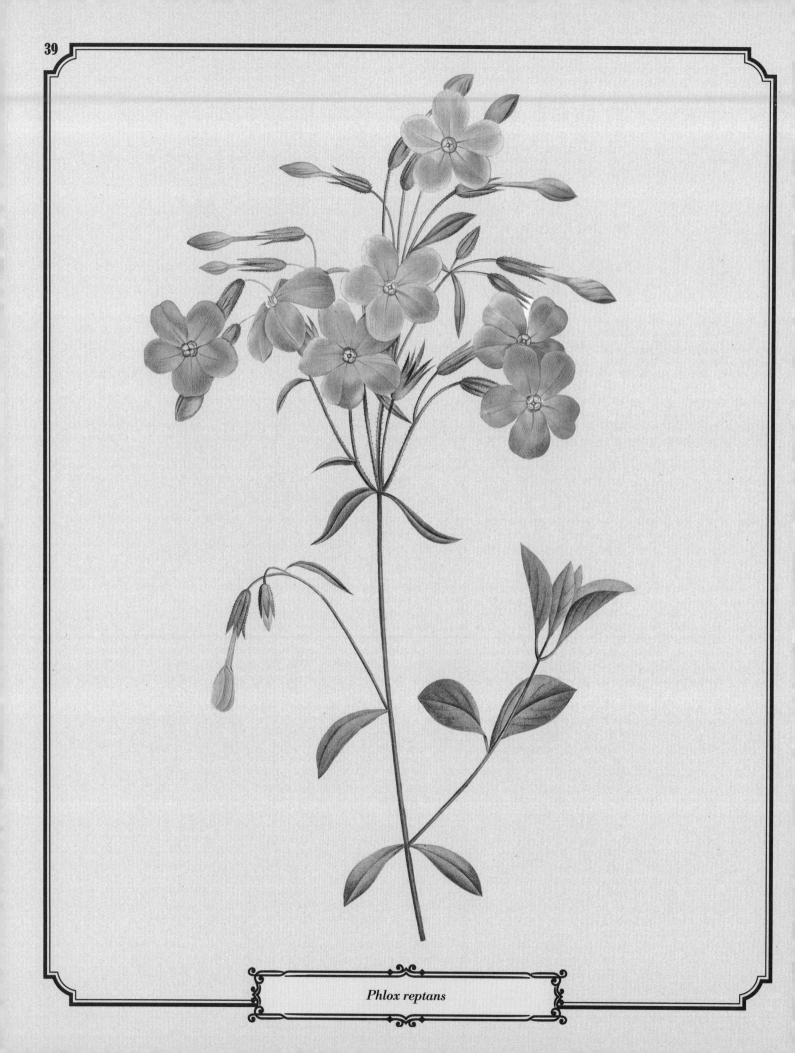

Phlox reptans

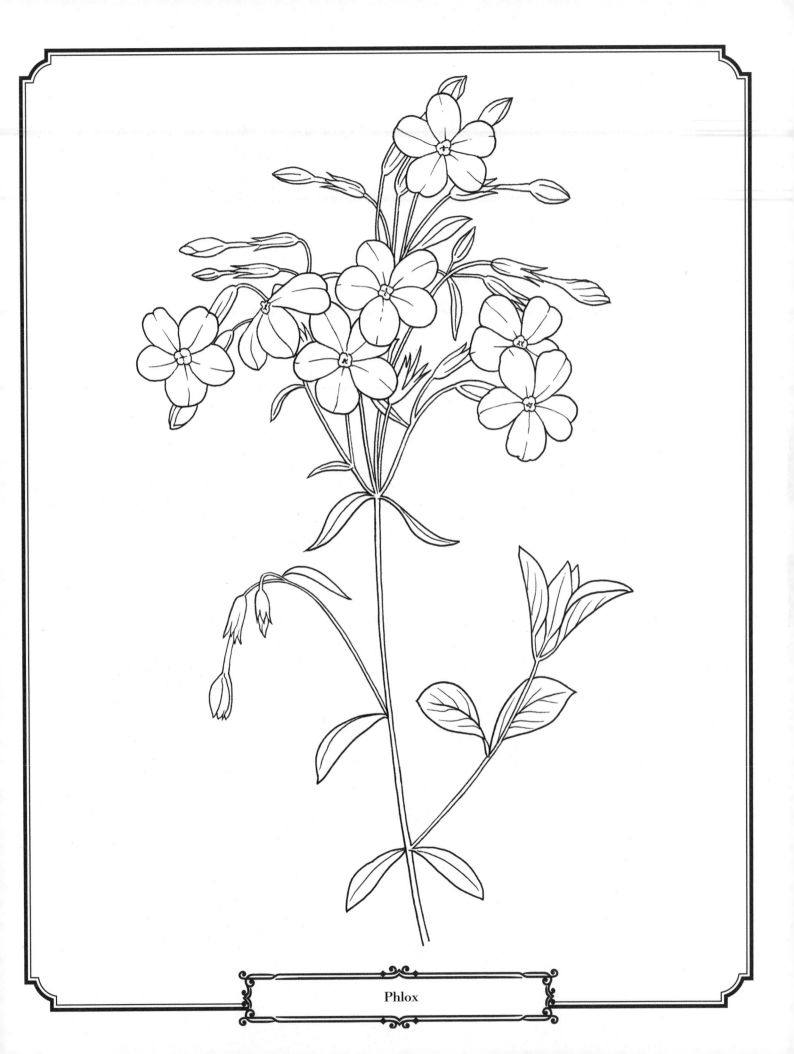

Phlox

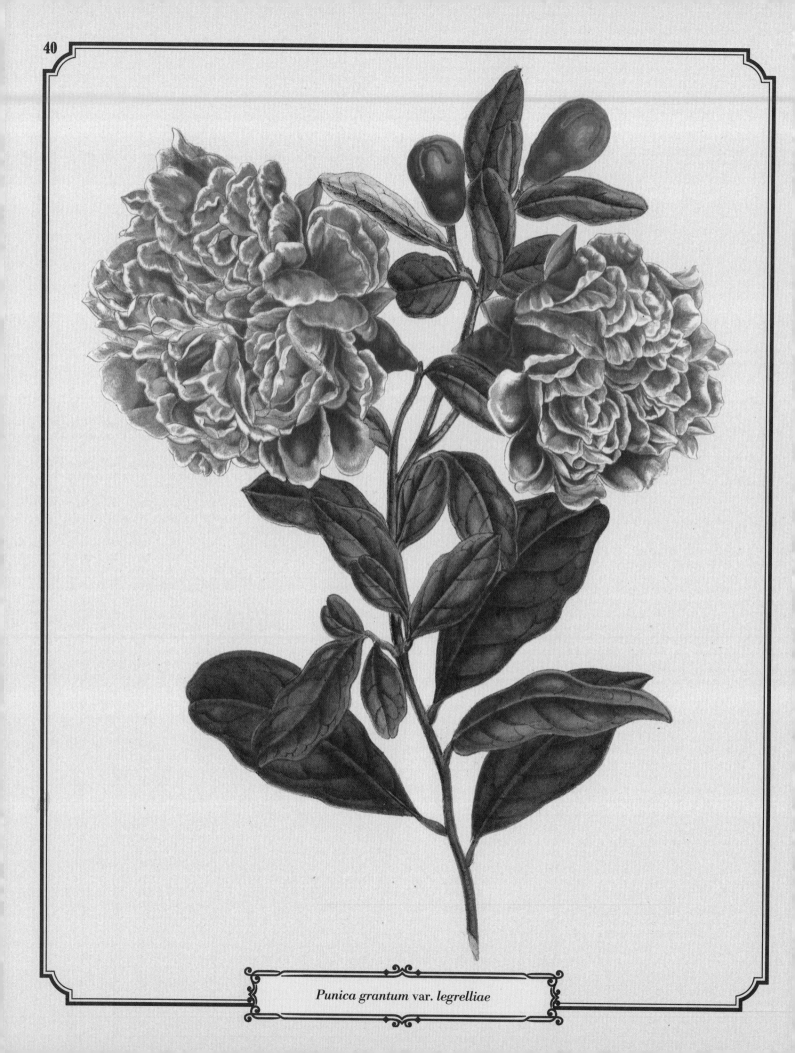

Punica grantum var. *legrelliae*

Flowering pomegranate

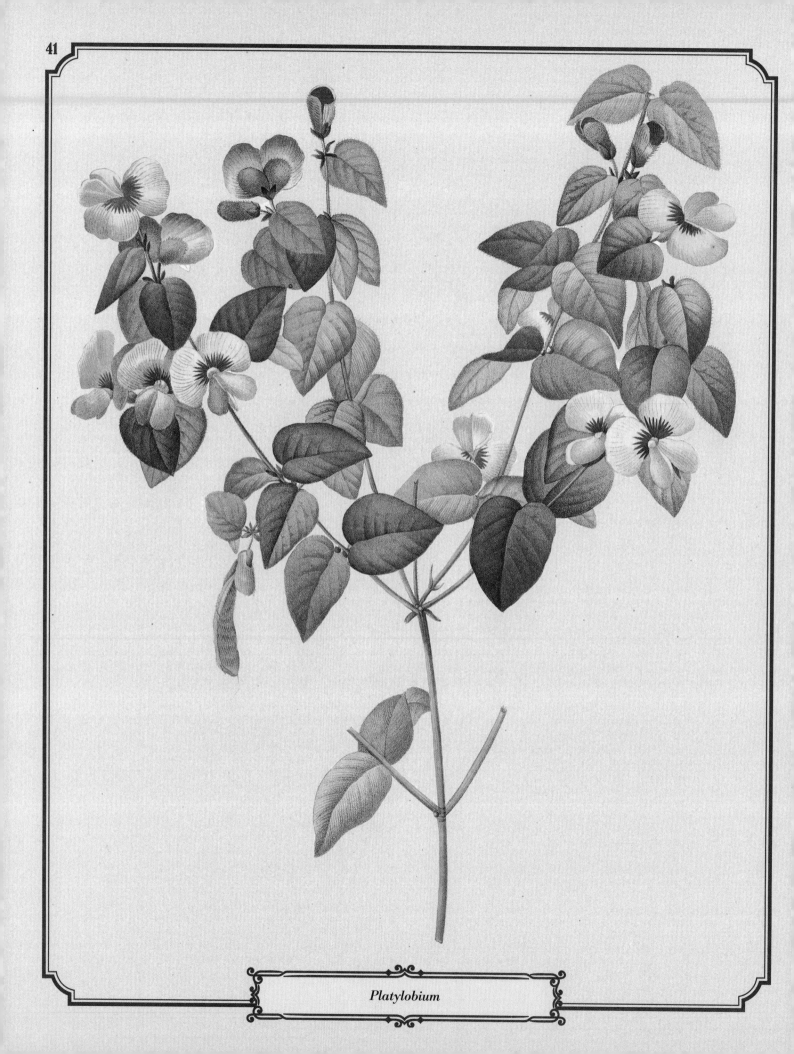

Platylobium

Flat-pea

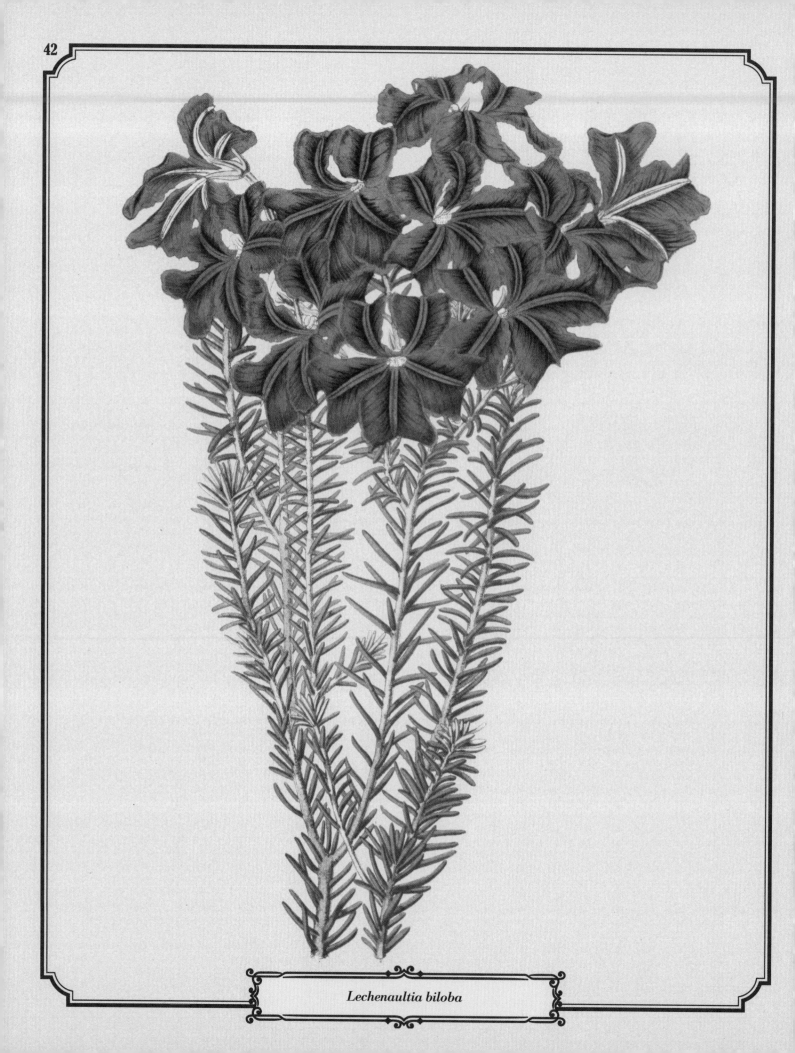

Lechenaultia biloba

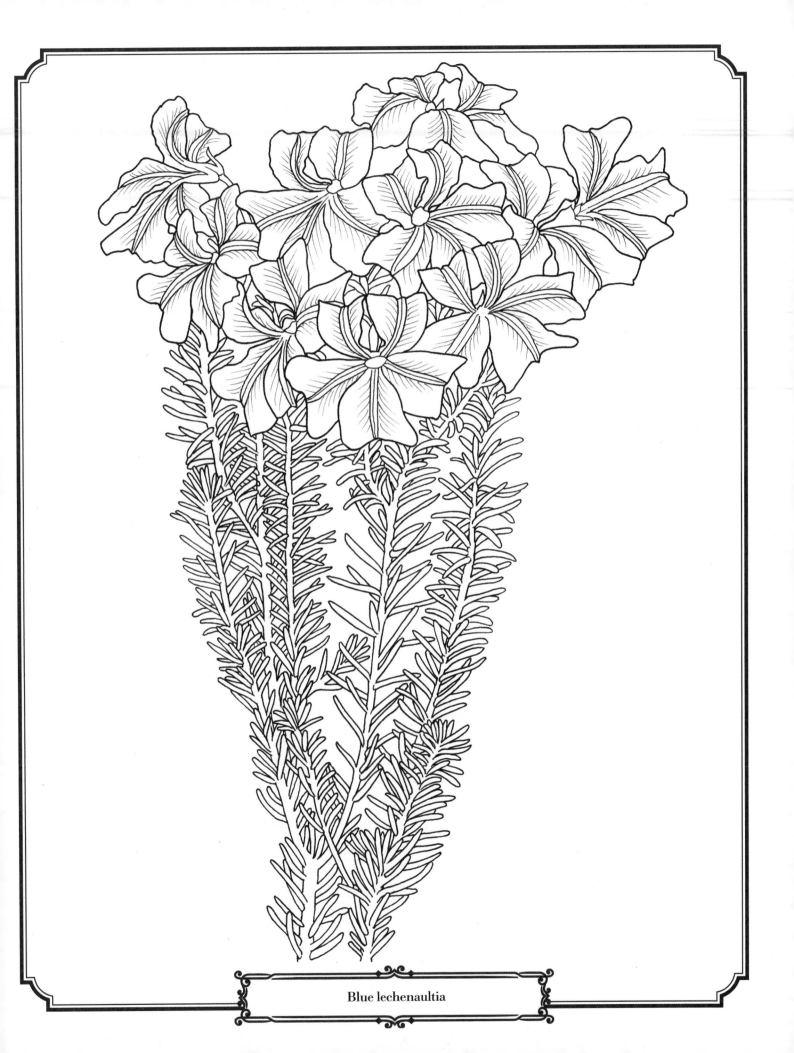

Blue lechenaultia

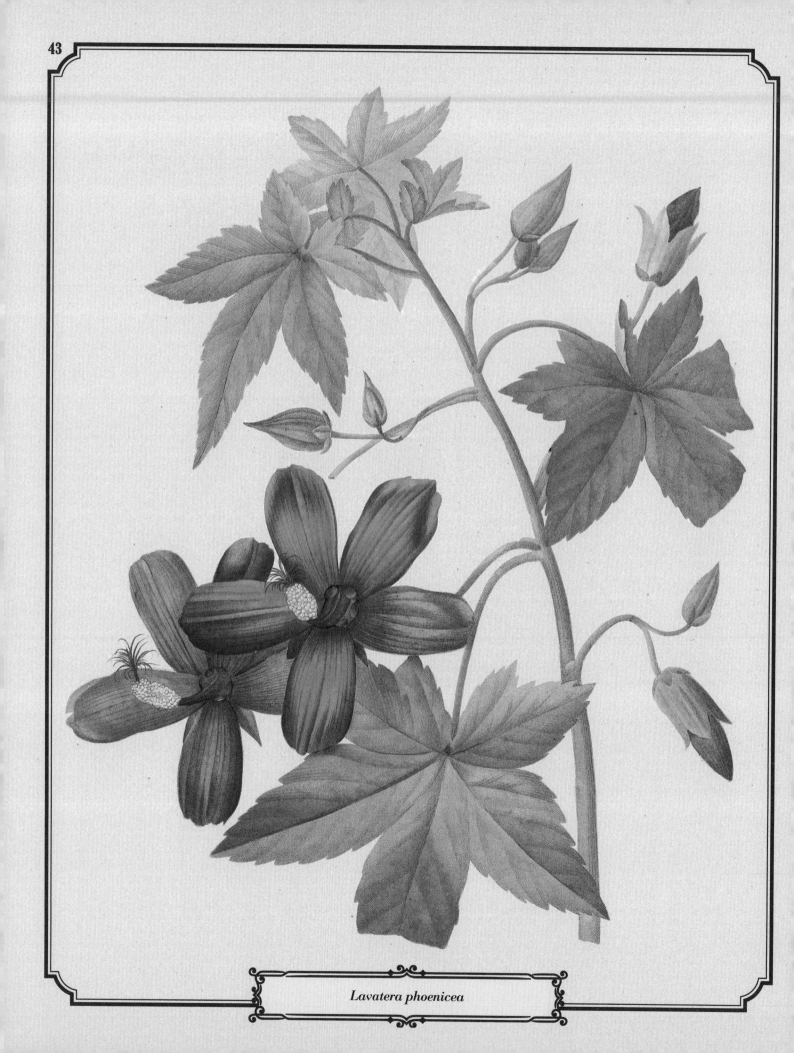

Lavatera phoenicea

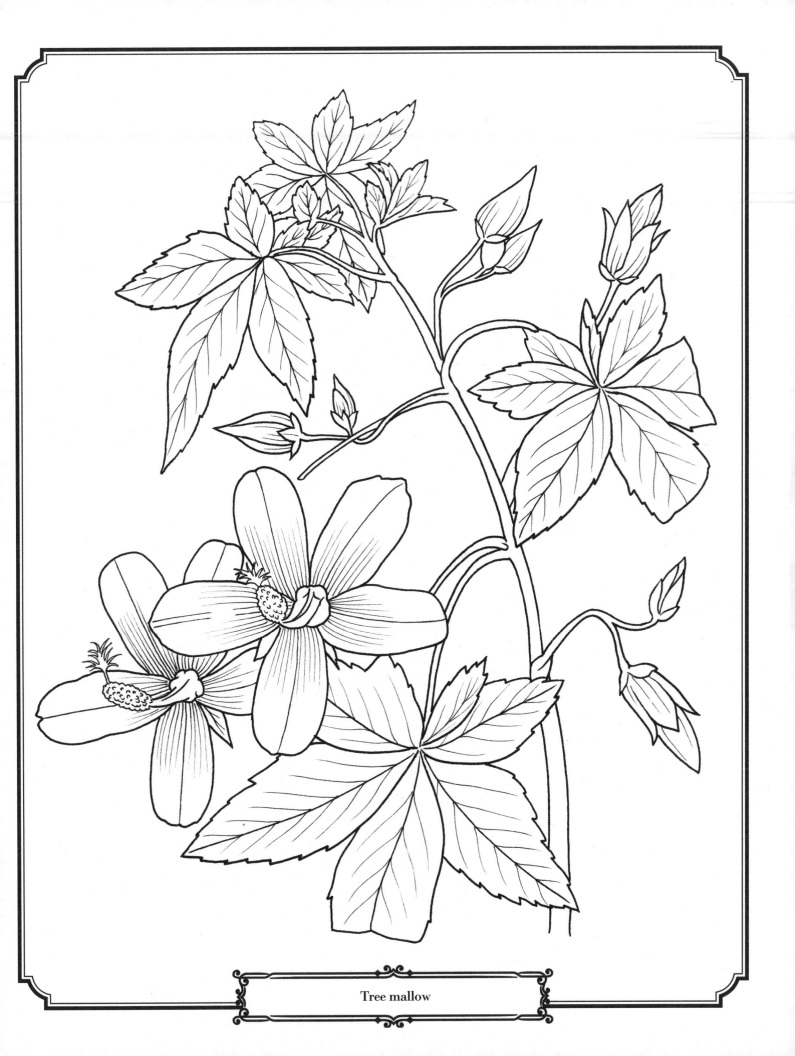

Tree mallow

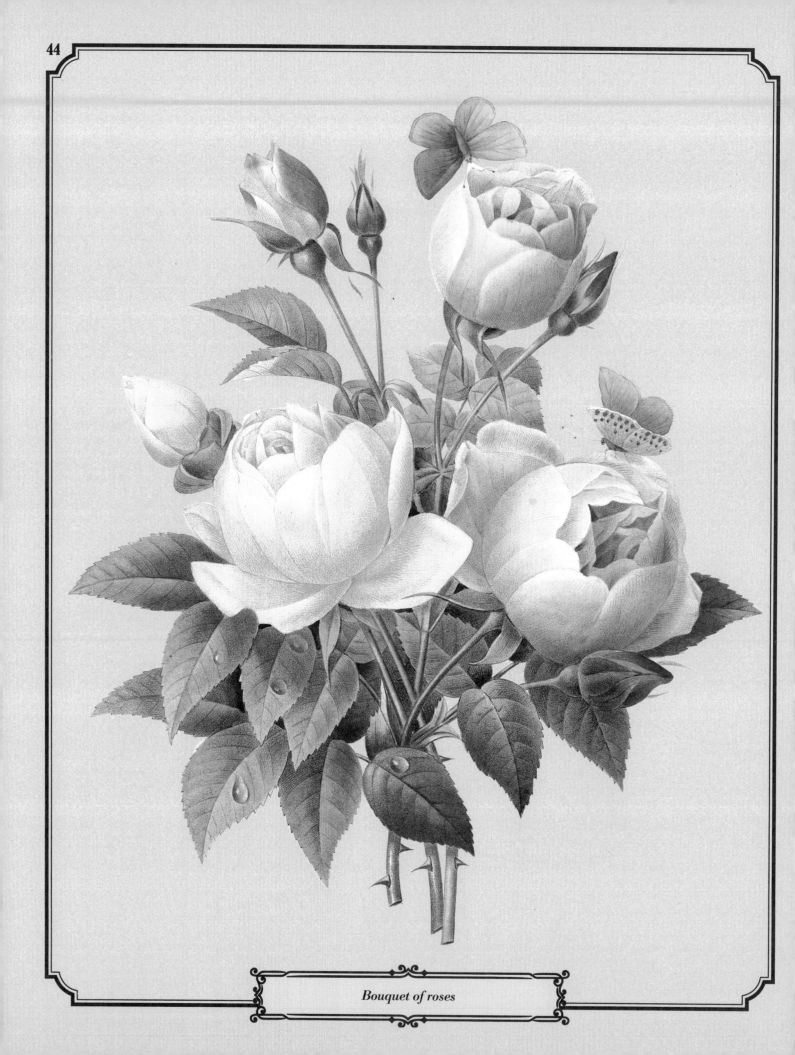

Bouquet of roses

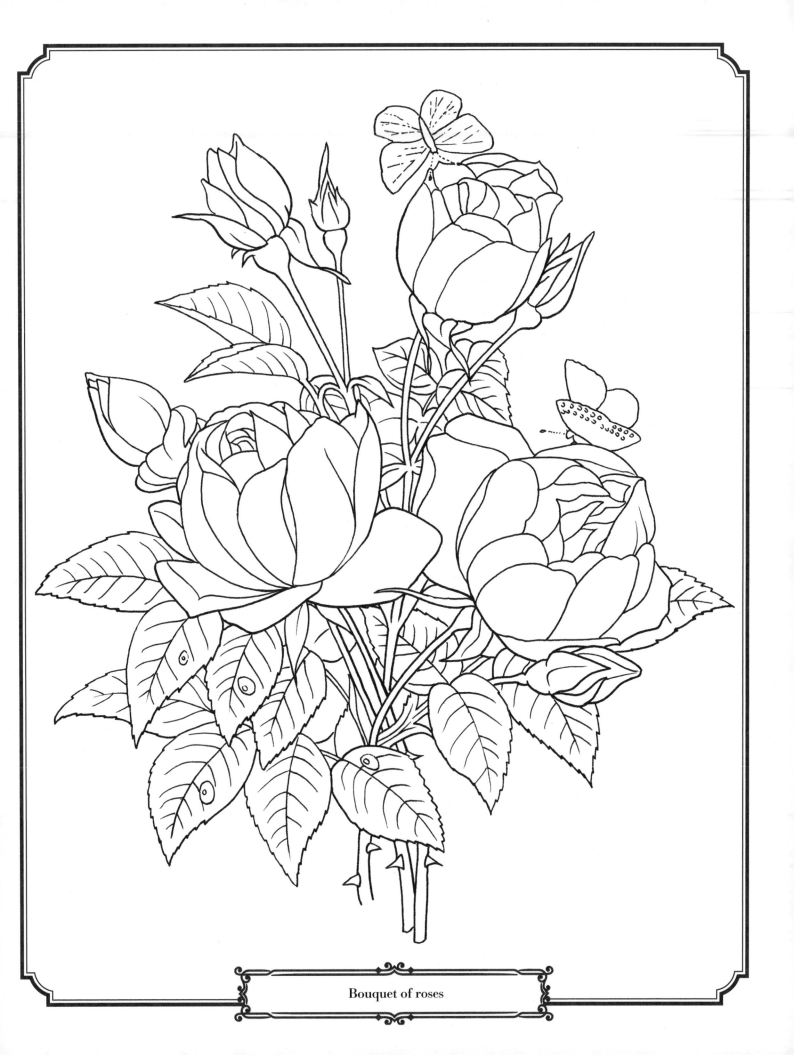

Bouquet of roses